ANGLESEY GHOSTS

ANGLESEY GHOSTS

BUNTY AUSTIN

AMBERLEY

First published 2009

Amberley Publishing Plc
Cirencester Road, Chalford
Stroud, Gloucestershire, GL6 8PE

www.amberley-books.com

British Library Cataloguing in Publication Data.
A catalogue record for this book is available from the British Library.

ISBN 978 1 84868 150 7

Typesetting and origination by Amberley Publishing
Printed and bound in Great Britain

CONTENTS

FOREWORD

Since I completed *Haunted Anglesey* two years ago I have been inundated by phone calls, letters from abroad, and even visitors telling me how much they enjoyed the book, and when was the next one going to be published?

So here is *Anglesey Ghosts*.

Readers will notice two changes in this one: it contains photographs of some of the haunted places, and it has been compiled by myself and my husband Walt. We gather the stories and arrange them – then Walt does all the typing.

Not only that, but he has an almost infallible sense of direction, finding his way to the most remote villages or houses which are accessible only along winding tree-lined unmarked old tracks and lanes.

This is an invaluable gift that I can only marvel at, I have no sense of direction – I could get lost in a telephone box.

Besides all that he is also a very accomplished photographer, so what more do I need? As he is a qualified technical engineer (and therefore very practical!) it took a great leap of mind-set for him for him to be convinced there was something else running alongside this material world. But now, after seeing and hearing unexplainable things, he is no longer a sceptic.

Bunty Austin

ACKNOWLEDGEMENTS

Once again I offer my heartfelt thanks to everyone who has taken the time and trouble to present us with even more ghost stories, undoubted hauntings, and unaccountable happenings which still occur on this fascinating island.

All these things were once taken for granted, part of our heritage, kept alive verbally until now but they seem to be fast disappearing in this arid age of technology.

These kind people include:

Tomos Roberts, BA DM PSA (Formerly Senior Archivist Bangor University).

For spending hours of his time searching amongst dusty archives and tracking down graves in churchyards. Nothing deters him from the trail of a knotty problem, which he always succeeds in solving.

Michael Bayley Hughes, MA (Wales).

For the endless flow of information and unstinting sharing of names, places, and people with stories, and pointing us in the right direction when our own information has been a bit vague. Not forgetting the photographs that he and Tomos Roberts have supplied.

Mary Aris, BA DAA MSC (Sussex).

A veritable fount of information about Beaumaris Gaol, and also to Mr Alun Jones and his team for their great kindness to us, providing details of the gaol itself.

John Sparkes (writer and presenter ITV Wales) Judith Davis and the crew for kindly interviewing us for inclusion in his TV series *Ghost Story*.

Ann Venables (County Archivist Mon).

Who guided us through hundreds of old newspapers and documents regarding murders in Anglesey over a hundred years ago, and kindly showed us the relevant files.

Martin Owen (Calor Gas).

Who very kindly got in touch with us, and brought us up to date regarding the Flame Family.

Lastly, thanks to all the contributors who are named in the stories, and without whom this book could not have been compiled.

I

MURDER MOST FOUL

I sat at my desk one morning last winter, and gazed morosely out of the streaming windows trying to make out where the grey of the sea ended and the grey of the sky began.

I'd been sitting there for at least an hour, and the page in front of me was only half-full. Usually the words flew rapidly across the pad, but this morning they were more like a few wet cornflakes sticking soggily to the sides of the of the plate, refusing to move.

Then the phone rang. If I'd known what a long and arduous task of ghost hunting I would embark on by the simple task of answering it – would I have done so?

Of course I would. Sheer curiosity takes over.

A woman's voice came on, and asked diffidently if I was the Bunty Austin who wrote ghost books? I assured her that I was, and she asked me if I would be interested in a very weird experience she had had during the Christmas just passed, in Holyhead? And please, if she told me, would her name be kept secret?

I told her that many people want their names to be withheld but could I use her Christian name? Certainly, she said, and her name was Helen.

As usual I asked her would she like to come and see me, or I could go to her, whichever was more convenient for her, so I could tape her story – I thought she was local, but she laughed and said she was phoning from Stanley Road Bootle, Liverpool, where she lived. That was too far away for a visit, so we agreed that I would phone her and tape the interview, and arranged a time that suited us both.

This turned out to be the following Tuesday, she answered on the first ring and told me this remarkable story, which I duly taped, and tell it in her own words.

'My husband Harry,' Helen began, 'is a seaman, he was born in Anglesey, and still has relatives there, who now live in Holyhead.

We visit them there every year, and just before Christmas we went over to his sister's family to take their presents and stay over the weekend.

It was nice seeing them all again, the kids were all excited about Christmas, the tree and decorations were great, and we all felt very happy.

We had our lunch, and a good natter, then when it got towards tea-time I told Jill I would go and get fish and chips from the chippie nearby, and she said that was a good idea and she would put the plates to warm.

I took a shopping bag to put the chips in, so they wouldn't get cold, and got myself wrapped up before I set out.

The weather was awful, wet and very windy, and dark of course, it being December. Well, I got the chips, and on the way back I was walking with my head down against the gusty wind when suddenly it happened,'

Helen paused so long here I thought she'd gone, so I said 'What happened?'
'Well,' said Helen, you probably won't believe this'

'Try me,' I said.

'Well, as I said I was struggling along in this freezing wind, when suddenly everything went dead. It became so quiet I thought I'd gone deaf, and that wasn't the only thing – I just couldn't move my legs – it was as if I was paralysed – the world seemed to have stopped.' Helen paused again, so I waited whilst she collected her thoughts.

'When I looked up, everything had changed. There were no street lamps or houses. No street in fact.

I was standing on grass instead of pavements – it was as if I was in a different place. The light was weird too – although it was dark – could see everything – sort of grey and black like the old films were. Not only that, but the heavy rain and the wind had stopped, everything was quiet – it was so eerie!

Instead of houses, there were dug-out ditches in squares like the foundations of a building or something, but they were flooded.

There were two figures about three yards in front of me. It was a man and a woman, he was burly and bigger than she was, I could see them as plain as day – even though it was night time!

Me: 'Were they transparent or solid?'

Helen: 'Oh, they looked solid enough, but wrong somehow, as if they weren't real.'

She stopped talking as if she was reliving the scene again in her head, and was quiet for so long I said 'Go on Helen – what happened?'

'Well,' she said slowly – 'she had her hand on his arm, and was looking up into his face then she tried to put her arms round him – they were talking to each other, I could see their mouths moving, but I couldn't hear a sound – it was the silence that seemed so wrong.

Anyhow, he grabbed hold of a little scarf she was wearing, and tried to pull it off, then they started to struggle and fight and fell down. Her arms were flailing about but he was on top of her – doing something to her throat, and after a bit her legs stopped kicking and she became still.

It was horrible – I was sure she was dead.'

Me: 'Then what happened?'

Helen: 'They just vanished, one minute they were there in the grass and mud – next everything disappeared and I was back on the street with the lights and the houses. The wind was still blowing and the rain falling, everything was normal. I was paralysed for a moment – then I came to life. I was just standing there with my bag of chips – I wondered if I was going mad. I felt scared to death – I knew the woman was dead, the way she had laid so still.

I hurried back to my sister-in-law's, I didn't say a thing because the children were there – but I – but I must admit I gave most of my chips to the kids; I couldn't eat.

My husband kept looking at me and he said "Are you alright? You're a bit quiet."

But I just shrugged and said "I'm – I'm fine".

He doesn't believe in things I've seen. I've tried to tell him in the past but he always gets angry, sometimes I think he believes I'm making them up, so I just keep my trap shut these days.

You see, last year my friend Mary came to see me from Everton. I was in the kitchen and she came in the back way, and she tapped at the window before she opened the door.

She was just going to close it after her when I said:

"Be careful, mind you don't trap Fly!"

(Fly was Mary's much loved Border Collie.)

Mary stopped dead, went pale and said:

"That's what I've come to tell you, Fly died last week!"

Then she burst into tears but I comforted by saying he was still with her.

Little things like that – it's happened before, but I've never told anyone about it, in case they think I'm nuts.'

She stopped and waited for me to say something. I was interested, but I didn't want her to lose the thread of her story, so I assured her that it was a gift she had, I did believe her, but would she mind if I asked her a few questions?

She didn't, so I asked her my usual questions:

How long did the scene last?

What kind of clothes were they wearing?

Were they aware of her?

Helen had already told me that they looked solid, so that was one question already dealt with.

'No' she said, 'they weren't aware of me – like I said, they were as solid as you and me, they seemed to be in a different time somehow.

They were dressed in old fashioned clothes, her coat was very long, almost down to the ground, and she had a dark hat on with a brim – it looked as if it was made of straw, something light like that, with a bunch of flowers or something at the side. It fell off in the struggle, she looked as if she was dressed up.

He was a workman I think – he looked a bit rough, he was wearing a cap and a buttoned up waistcoat, with a top coat and trousers. The whole thing only lasted a minute or two, but when he bent over her, I was sure he killed her.

I've never forgotten it, I couldn't do anything to help her, because I knew I was seeing something *that had already happened.*

After I read your book, I just wondered if anyone else had seen the same thing and told you – and what really happened?'

I told her I hadn't heard a thing and I'd only ever been to Holyhead a few times, but I'd try and find out if anything had happened on that spot. Give me a couple of weeks, I said, these things take time to follow up.

When we had finished the call, I sat at my desk for a few moments, wondering where to begin.

Well, obviously a visit to the Archives at Llangefni, that not only hold thousands of records but is staffed with ever helpful and patient ladies.

First, though, I would phone my trusty friend Claire Meade who was born and brought up in Holyhead. This I did, and asked her if she knew of any murders that had taken place there.

'No, not that I've heard anyway – whereabouts?'

'I think she said near Newry Street.'

'Oh that was years ago – before I was born, before the first World War, there was a rhyme the kids used to chant when they were skipping'—

'William Murphy killed Gwen Ellen,
On the road to Porth-y-Felin-'

She actually *knew*! Now I had some facts to work on, besides the vision that had happened to Helen.

Next came a lengthy visit to Llangefni Archives, which bore a great deal of proof about the killing.

It was reported in full in *The Chronicle* 28 January 1910.

The headline was 'Holyhead Murder – Murphy sentenced to Death!'

The report was very detailed, and if I wrote it in full, it would be a book in itself, so I have tried to give a shortened version of the story, without omitting background details, which give a sense of the drama as it unfolded.

Firstly, Gwen Ellen Jones was thirty-five years old when she met her violent end. She was the daughter of one John Parry of Bethesda.

A married woman with a son of seven and an adopted daughter of thirteen.

She had left her husband years before, and had lived with another man (name unknown) before leaving him and going to live with yet another. Finally, she returned to her father's house to live in Bethesda, with both the children.

It was whilst she was there that she did the washing for William Murphy, a handsome ex-soldier, years older than her, and they fell in love. But he had a violent temper, used to beat her unmercifully, and although she was afraid of him, she knew there was a kind side to him and thought maybe she could tame him. They even lived together twice, for three weeks each time, but he didn't change, and finally she returned to her father's house to live.

William Murphy managed to get a temporary job labouring in Yorkshire, from where he sent Gwen Ellen small sums of his hard-earned money.

Unbeknown to him, about six weeks before Christmas 1910 she left her home at Bethesda and went to live with a man named Robert Jones in Holyhead, taking her little boy with her.

Two weeks before Christmas William Murphy returned to Gwen's father's house, expecting to find her there. Knowing his violent temper, her father intentionally misled Murphy by saying he believed Gwen had gone to Beaumaris to live with a friend.

Murphy was furious and said if he found her with another man he would kill her, he had been sending her money that he could ill afford and, as far as he was concerned, she belonged to him.

He stormed out of the house, saying he was going for a drink.

At the local pub in Bethesda, he was told that Gwen Ellen had gone to live with another man in Holyhead, and he lost no time in making his way there. He inquired there as to her whereabouts – he even asked the police, telling them that she had treated him badly and that he would 'give it to her'.

Remember, in those days there was a shifting population in towns, especially in ports, of poor people who went where they could get a job, and as most of the work was of a temporary nature, they lived where they could, mostly in lodging houses that could provide them with a roof over their heads and a bed (of sorts) for a few pennies a night.

The houses were fairly crowded, everyone bought their own food and stored it in the kitchen cupboards. People drifted in and out so frequently, sometimes they didn't even know the surnames of their fellow lodgers.

Such was the house at 51 Baker Street, where we find Gwen Ellen, living with Robert Jones.

Finally, Murphy tracked her down and, unbeknown to Bob Jones, they resumed their relationship, made more easy because Murphy went to live at 40 Baker Street, rented by Johnny Jones. (No relation to Bob.)

They saw each other every day between Monday and Saturday of Christmas week. She told him she would not leave Bob and he was so angry and jealous he 'thrashed her until she was black on the Thursday,' said a witness at the trial.

By now Gwen Ellen was quite afraid of him and went everywhere with her friend Lizzie Jones. When Murphy arranged to see her at the bottom of Wynne Street at 7 pm on Christmas Day evening, she went instead for a walk and a drink with Lizzie. As she did not turn up, Murphy went around the pubs looking for her.

He was in the Bardsey Inn with John Jones when Gwen Ellen and Lizzie peeped through the window. (Were they hoping he wasn't in?) John saw them and pointed to Murphy 'There she is!'

So Murphy strode out, Jones following, and said furiously to Gwen 'Gwen, where have you been?'

'I went there at 7 o'clock and you did not turn up,' said Gwen. Murphy knew she was lying, he'd waited there for her.

At this point, not wanting to be part of a quarrel, John Jones went back inside the pub.

'Well, will you come for a walk with me now?' demanded Murphy.

'Yes', said Gwen, probably thinking Lizzie would come with them and therefore feeling safer.

'On our own,' said Murphy glaring at Lizzie.

At the trial, Lizzie was asked if Gwen had said anything to her at this point, and she answered 'Yes – she said – '

'It doesn't matter what she said,' Murphy's defending solicitor snapped.

(Murphy didn't hear what Ellen said to Lizzie – was it a plea for help, or some instruction? We will never know now what Ellen's last words were to her friend.)

Seeing Murphy's scowling face, Lizzie turned and went back into the Bardsey Inn.

We'll take what happened next from Murphy's statement to the police.

'I should have met her tonight at the bottom of Wynne Street between seven and half-past. She didn't turn up so I went to her house to look for her, but she wasn't there either. I tried the Bardsey Inn, no luck, but whilst I was drinking, John Jones said 'There she is,' and pointed to the window. I went outside, and she was talking to a ginger piece.

She said she had been to the stile and I wasn't there, I knew she was lying. She was drunk. I said, "Will you come for a walk with me now?" She said "yes", so we had a walk by Captain Tanners house.

She kept falling against me drunk, and said "I like you." I said, "Why don't you pull this thing off?" Meaning the muff she wore around her neck.

She said, "It's hooked underneath."

I then got hold of her with my left thumb, and tried to strangle her. She screamed, and I held her down with my left hand. She grew weaker and weaker, until she gave her last kick. Then I drew my knife out of pocket and started cutting her throat, and when I had finished cutting I dragged her into a drain.

She was still alive when I got her into the drain, so I started to cut her throat again from ear to ear, then I turned her face downwards and shoved her underneath the water to drown her. I must have dropped my knife then.

After a bit, I lifted her up the embankment, she was very heavy, so I tried to drag her up by her hair, but my strength gave out and she slid back into the water, so I stood and swore, then I left her and went to find a pub, and I ordered a pint of porter.

The barmaid said, "What's the matter with your face, it's all scratched?"

I told her I'd been fighting. I had another pint of porter and, when I'd drunk that, I went back to my lodgings.'

John Murray of 40 Baker Street, where he and Murphy lodged, said that about 9.30 pm on Christmas Day Murphy came into the house very hurriedly. His face was scratched and he had blood on his shirt. He took his food out of the cupboard and offered it for sale. An old man bought it for 2d. Then he took off his top coat and offered it for 3d.

(Surely that must have been heavily blood stained? Author.)

'Hurry up with the coppers,' he said, 'I have no time to wait.'

Someone bought it, and Murphy turned to leave. As he was going out, he said to John Murray.

'Speak of me as you find me.'

'I can't do anything else' said John.

'I have done wrong tonight,' said Murphy, and left.

If he planned to run away, he must have changed his mind, because when Lizzie went back from the Bardsey she found Murphy sitting on the bed on the ground floor. His hands and face were covered in blood, and one side of his face was scratched.

There was no sign of Gwen-Ellen, and when Lizzie asked him where she was, he said 'You have seen Gwen-Ellen for the last time, you will see her no more.'

When he said that, Gwen's little boy, who was in the room, started to cry for his mother, and Murphy told him he hadn't got a mother and gave him a penny.

He asked Johnny Jones if he would give the boy a piece of bread and Johnny said he would if there was a piece in the house.

Then she asked him what had happened to his face, and he said he had been fighting with two men in a field.

He turned to Johnny and asked him if there was anyone in the house who would do a job for him.

Johnny asked what the job was.

'Go and fetch a policeman for me' said Murphy.

'You haven't had enough drink for me to fetch a policeman.'

'It's worse than drink,' said Murphy, 'come and see.' And they left the house.

Murphy took Johnny Jones to the trench where the body lay, and a terrible sight awaited him.

It was described thus by Doctor T.W. Clay (Holyhead) who examined the body and gave evidence.

'I was called to Holyhead Police Station on Christmas night where I examined the body of Gwen Ellen Jones.

Her mouth was frothy, her eyes were protruding, and a fur necklet she had on was saturated with blood.

Under it was a wound from ear to ear, about five inches long, also a gaping gap being three inches wide – and the whole windpipe had been severed, with the gullet, arteries, and all the main structures down to the spine. The wound was a bit jagged so far as the deeper parts were concerned.'

The judge showed him a broken kitchen knife,

'Could this knife have produced the wound?'

Doctor: 'Yes'.

(I couldn't understand why the wound from top to bottom should be as wide as three inches, then it suddenly dawned on me that Murphy had dragged her up the embankment by her hair, women favoured long hair in those days, and the dead weight of the body, plus everything severed bar the spine, must have almost pulled her head off. Author.)

Dr. Clay went on to say he had performed a post-mortem on the body on 28 December, and in addition to what he mentioned, he made special examination of the larynx, which was crushed above the wound, and this could have been done with a hand.

All the other organs of the body were bloodless, showing that there had been a great deal of hemorrhage. The cause of death was primarily strangulation, secondly hemmorhage.

Horrified, Johnny stood unable to move for a moment, then took to his heels and ran. According to folklore 'he ran so fast it was as if flames came from under his feet.' In fact his whole family became known as the Flame family and are still known by that name today.

This isn't as far-fetched as it sounds, because nearly all working-class men wore clogs then, with clog-irons nailed on the sole, so that when running the clog-irons striking the paving stones would emit showers of sparks.

Johnny ran distractedly around the streets looking for a policeman. When he had found one, and gabbled out his story, they both hurried to the police station, and, to Johnny's surprise, Murphy was standing outside the station leaning back against the wall.

When he saw them coming, he said:

'Are you looking for me? I've come to give myself up, I've killed a woman with a knife.'

He searched in his pockets for a knife, but he had inadvertently dropped it in the drain. It was subsequently found between two stones at the scene of the crime and was a broken kitchen knife.

As the murder had happened on Anglesey, Murphy had to be tried at the Anglesey Assizes, held in Beaumaris Court.

The sentence of death had not been passed at Anglesey Assizes since 1862, and the Island seethed at the excitement as the day of the trial (Wednesday 26 January 1910) arrived.

Brakes (precursors of charabancs) were run in from various parts of the country, heavily laden farmers carts rumbled in from early morning. The Bangor Corporation ferry had it's most prosperous January day for many years, and an excited crowd gathered outside the court an hour before it opened.

Murphy arrived in a closed carriage drawn by two horses, and the crowd surged forward, before being dispersed, with difficulty, by the police.

The people hissed, booed and hurled curses at the murderer, and would surely have put him to death if they hadn't been restrained. When the public were admitted the

building was filled within a minute, and the most unlikely positions were taken up. Even the broad window sills were occupied by two tiers of people.

Officials called the attention of the police to the fact that some men still had their hats on, and the police told the men they would be ejected if they didn't show more respect for the court.

There were scores more outside, and several men scaled the walls to the windows, and with their heads inside and their bodies outside they listened to the case. One of them was reproved by the judge who said: 'If that gentleman with his head through the window wants to listen to the case, he will have the goodness to remove his hat.' Instead, the gentleman, with the aid of a policeman, was removed bodily.

Murphy was tried and found guilty by the jury, who only took three minutes to consider their verdict.

When the judge assumed the black cap, he asked Murphy to stand to receive the sentence. He did so with alacrity, standing to attention, and smilingly said 'Thank you, Sir,' when the judge delivered it.

He was taken down to the cells, amidst the howls and boos of the crowd, and later emerged, securely handcuffed, and was bundled swiftly into a carriage to spend the night in the cells at Holyhead, before being taken to Caernarfon the next day to await execution.

Mr Peter Scott Roberts, the well-known local historian, told me that when Murphy was taken out of jail next day, the local townspeople, who hated and despised him for the cowardly murder of a woman, gathered outside Holyhead police station to see him, armed with sticks and stones to hurl at him.

In fact, said Mr Roberts, his mother remembers being told by her grandmother that her mother had taken all her children to see him being taken out of jail, and she had taken a loose brass door knob out of a room door in the house and had put it in her pocket ready to throw at Murphy, hoping to hit him hard.

But, as at Beaumaris, he was bundled between building and carriage so swiftly, people had hardly time to react.

Next day on the train to Caernarfon, Murphy pulled down the window about a mile and a half outside Holyhead and, pointing to a farm called Tre Goch, said to his police escort 'I meant to do the job there in the shed last Thursday, but she had her little boy with her, and I didn't want him to see it.'

He then sat down and remained silent all the way to Caernarfon.

As Beaumaris jail was by then closed, he was executed for his callous crime in Caernarfon jail where his grave headstone is still on display.

So, there were the facts of the matter, now I had to search for any other paranormal visions or incidents like the one Helen had experienced. I worked long and hard, with no luck. Mr Peter Scott Roberts did tell me that the Captain Tanner who was mentioned by Murphy was a sea captain, who owned a large house surrounded by fields. Holyhead at that time was a thriving port, growing rapidly, and Captain Tanner had sold off some of his fields to developers, who were busy erecting houses, and it was at one of these building sites that Gwen Ellen met her death.

I will not give the exact location, as people live in the houses now built and, as they are sold every now and again, you can understand that no one would buy a house with a dubious reputation.

By a stroke of luck, a gentleman called William Parry, a van driver from Holyhead, came to make a delivery at my home last month. He had read *Haunted Anglesey* and knew I was researching the Gwen Ellen murder.

His grandmother (now dead) had known the exact spot where the murder took place, having been shown by her auntie when she was a child. He also told me that his wife went along that particular street to get to the shops.

Last year, said Mr Parry, she was walking along with their son aged five, when she met a friend who had just had a baby, so she stopped to admire it, and to have a chat. It had been raining hard, and her little boy was floating bits of paper along the flooded gutter to the grid. Suddenly he stopped, dropped onto his knees and stared down the grid. Then he looked across the pavement to where the two women were gossiping and shouted urgently.

'Mam! Mam! There's a lady in the grid!'

'Mam come quick and get her out – she's crying – I think she's stuck.'

His mam sensed his urgency and knew it wasn't a trick, so she went to join him at the grid.

'Listen!' he said, 'she's crying and screaming, we've got to get her out.'

Both women now joined him and stared down the grid. 'Can you hear her?' the little boy said, grabbing the grid bars and trying unsuccessfully to raise it. 'Help me – it's too heavy.' The ladies now knelt on the pavement by him, and listened, but all they could hear was the rain-water splashing down the drain.

'I can't hear anything – can you?' Owen's mam asked her friend.

'Nothing – you must be hearing things,' said her friend.

But by now, Owen was in great distress.

'Please please,' he said to his mam, 'get her out'.

His mam was perplexed, she knew he wasn't playing tricks, he'd started to sob.

'Shush a minute while we all listen,' said her friend.

They knelt in silence, listening hard. Nothing.

'She's stopped' said Owen, 'she must be drownded.'

His mam stood and pulled him to his feet.

'Nonsense Owen bach,' she said, 'you must have heard the echo of someone's radio.'

It sounded false even to her, but she couldn't think what to say to comfort him. 'You see it's stopped now, and how could anyone be in a grid anyway? Come on, lets go home.'

Owen wouldn't be comforted, he sobbed all the way home.

'I was just getting out of the van when they got back, and Owen flew at me and gabbled out this weird tale, trying to make me go back with him.

He was quite distraught, and as it wasn't very far, his mam said it would better if I went with him – to ease his mind.

When we got there, the rain had stopped running down the gutter, and all was silent in the grid. I reassured Owen, until he was a bit more settled, but he was very pale, and hardly said a word on the way home.

We had a darts match on at the pub that night, and I was telling my mates about Owen thinking there was a lady down the grid. When I mentioned the street name, one bloke in the team said he had lived in that street once, but only stayed about six months because they didn't like the house.

Then he added, "The house was alright, but downstairs had a terrible atmosphere, you couldn't stay in the kitchen long."

I asked him what sort of atmosphere, and he thought for a minute then told me it was a mixture of rage and fear. His wife felt it more than he did, but in the end they left the house. They found out later that it was built on the spot where Gwen Ellen had been found.

It was his turn to play, but he lowered his dart and said

"I'll tell you the number of the house," (he did) "and just see if the grid was outside there."

Next day I went to look at the house, and see if the grid was near.

It was.'

2

THE VIOLENT GHOST

STORY ONE

On the road between Nebo and Llys Dulas stands an empty farm. The stone boundary walls which separate it from the road are over six feet in height, but are so smothered in ivy they are hard to see.

Long ago a garden was on the other side, but now the rose bushes have grown tall and wild, struggling for light amongst the over grown trees and shrubs.

The only thing which can still be seen is the little garden gate, half open and leaning drunkenly on its rusty hinges.

Three steps cut into the steep bank lead up to it, but it was only after we had worked with secateurs and sickle, cutting away thick nettles and long grasses, that the stone steps were revealed.

We mounted them, and peered over the top of the gate at a jungle, which had once been a pleasant garden, but was now thick with many years growth of lush weeds.

Now we could see the house itself, standing high above on the bank, and we stood and looked at it in silence.

The blank windows stared back at us – the empty façade giving no indication of the secrets that lay within. The silence was unbroken, not a leaf stirred and no bird sang. The atmosphere made me feel uneasy and we went no further.

Some of the house's secrets will probably never be revealed, but we managed to unearth a few of them by dint of a lot of detective work and invaluable help from friends.

Firstly, I was told of the hauntings by Mr Les Jones of Dulas, whose terrifying experience I have left until the end of his narrative, as it deserves a separate place of its own.

Les put me in touch with Mr and Mrs Barry Jones (currently living in Pen-y-Sarn) and this is what Mrs Jones told me:

'My husband Barry and I moved into the house in the mid-1960s, with our two little girls.

There were no problems at all, except for the odd night when we heard bumps and footsteps upstairs, and Barry would say:

"Sounds as if the girls are up."

So I'd go up and the girls were fast asleep. We just put it down to the house being old, because there are lots of creaks and thumps in old houses aren't there?

The gateway where Les (Stag) Jones was attacked. You can see a glimpse of the haunted farmhouse in the background. (Photo courtesy of Walt Austin)

We lived there quite happily for about four years, just ordinary lives, and then something happened to change it all.

It happened like this:

My sister Joyce and her husband Geoff came to the Island, and they bought a cottage which needed a lot of restoration, it was almost falling down.

We arranged that they could come and live with us, Joyce would get a job in Amlwch, and Geoff would join Barry's firm as a plasterer, Barry needed a plasterer so they would fit in nicely.

We made a room at the back of the house into a bedroom for them, it was a bit small as it had been the maid's bedroom when it was a working farm, we made it nice and cosy for them, and as it was over the kitchen it was warm and snug.

They arrived alright, and I helped Joyce to unpack, there was quite a lot of stuff, because she didn't know how long they would be staying.

We spent a pleasant evening nattering, then Joyce and I left the men downstairs while we went up to bed.

Joyce went first, me following, and after we'd said goodnight she turned to go into her room.

Then, just as I went into our room, she gave a piercing scream – frightened me to death it did!

I turned around to look at her, and she was standing at the end of the landing with her arm thrown up in front of her face as if she was protecting herself from something.

"Good grief, Joyce – what on earth's the matter?"

She was shaking like a leaf, and she ran back along the corridor and flung her arms around my neck.

"That man – that man – he's blocking the door – he won't let me go in!" she blurted, pointing backwards.

I looked at the door, there was nothing there – nobody on the landing except the two of us.

The men had come dashing upstairs when they heard Joyce scream and Joyce ran at once to Geoff and stood sobbing in his arms.

Well, we were all baffled, the men went in and searched the room – it was quite empty, and I could see by their faces that they thought she was being hysterical, so did I in a way, although she wasn't a fanciful girl.

We calmed her down, Geoff led her into the bedroom, and said she must have been seeing things, and they put it down to the stress of moving. So they went to bed, and the rest of the night was peaceful.

She was still edgy next morning, and when we were alone I asked her what she had seen.

"It was a ghost – I know it was," she said, clasping her hands together, and staring into space.

Well, when someone says they have seen a ghost you think about something in a long white sheet – at least I did, and her next words made me think again.

"It was a man, a tall man, he had thick black hair and deep set eyes, and he was staring at me as if he hated me."

"What was he wearing?" I asked curiously, still not convinced. "He had a First World War soldier's uniform tunic on, khaki coloured, with a long row of buttons down the right hand side," she said promptly, "but although he was tall – he had no legs!"

I knew she was telling the truth – she was so positive about it – I just didn't know what to say.

"Was he a soldier?" I asked stupidly.

She shrugged. "It was a very old tunic, torn in places, I don't think he was a soldier."

"And he had no legs?" I asked.

She shook her head. "No," she said briefly.

I couldn't understand this bit, but a psychic friend of mine said it could be that the ghost hadn't materialized fully.

When I asked her if he was coming towards her, she said no, he was blocking the bedroom doorway with his hands outstretched in front of him, forbidding her to go in.

Well, things were quite peaceful for a time after that, Joyce got a job in a chip shop in Amlwch, we only saw the men briefly in the evenings, because after tea and at weekends they went to work on the cottage.

Joyce hardly saw Geoff at all as she worked late at night, so she was still fast asleep when Geoff got up in the morning. Usually each morning, when the men had gone to work, and we'd got the children off to school, Joyce and I would have a cup of tea on our own in the kitchen, before we started to do the housework.

One day Joyce got up looking pale and tired, so I asked her if she felt alright.

"Yes I'm OK" she said, "but I couldn't sleep last night, I kept waking up, thinking there was someone in the room – there was no one there when I looked around, but the atmosphere was all wrong somehow" she shrugged and shook her head.

"How do you mean – all wrong?" I asked.

She stirred her tea slowly, thinking to herself.

"Oh I don't know – it was kind of heavy – thick – you know, sort of threatening somehow."

I could see she was troubled, so I tried to make light of it.

"Serve you right for having cheese on toast for supper – no wonder you had nightmares!"

She nodded absently, but I could see she was still uneasy.

I got up to move the cups, and as I did so there came the most tremendous bang from upstairs. We both nearly jumped out of our skins – and looked up at the ceiling.

"What on earth?" I said, and was out of the room like a shot – pounding upstairs to Joyce's bedroom.

When I flung the door open I didn't believe my eyes. The room was usually very neat, Joyce was a tidy person, but now the room was in utter chaos. Bedding had been torn off the bed and flung into a corner, clothes had been thrown out of the wardrobe and onto the floor, and the bang we had heard had obviously been the chest of drawers (a heavy Victorian piece) which now lay on its face. Everything on the dressing-table looked as if it had been swiped sideways by a furious hand. Perfume bottles, make-up and small ornaments were in a heap and Joyce's jewel box was lying on the floor, its contents scattered all over the place.

I hardly had time to see everything before I heard a gasp behind me. Joyce had followed me up and stood in the doorway, her hands to her mouth and her face paper white. I thought she was going to faint – she wasn't the only one who was frightened but one of us had to keep our nerve, so I said:

"There's no one here. Whoever or whatever did this has gone – we better start clearing everything up."

I sounded calm enough, but underneath I was as frightened as she was.

So I marched in and started to pick up the pile of bedclothes from the corner of the room where they had been thrown, and I said to Joyce:

"Come on, help me to make the bed – I can't do it on my own – it needs two."

So she came in, very reluctantly, and started to help.

"It's alright Joyce – he's gone now – we're on our own."

She didn't say anything – just fumbled with the bedclothes, her hands shaking.

She was right about the atmosphere, the room felt heavy and thick somehow, like it does before a thunderstorm.

I shook out a sheet, she was standing at the other side of the bed, her back was to the dressing table – and suddenly, over her shoulder I saw her hairbrush rise into the air about a foot, and come slowly down onto the carpet.

He's gone now, I'd said – how wrong can you be?

He was still there – probably watching us, although we couldn't see him. I'm glad Joyce didn't see the brush move – but even so she looked at me and said:

"Oh Irene, I can't bear it – I've got to go down" and with that she ran out of the room.

Joyce was in shock all day, she sat pale and quiet, but when the men came home she blurted it all out.

They still seemed to be in some doubt, even when I said it was true, I could tell by their faces.

We had to stop talking about it when the kids came in for their tea, Joyce had a boy and a girl, we had two girls, they were all about the same age, and we didn't want to scare them.

Of course, she didn't want to go to bed that night, but she was with Geoff and that gave her a bit of courage.

She was very restless all night, but fell into a deep sleep towards morning, so Geoff slipped out of bed without waking her up. I got breakfast for everyone, and they all got off to school and work OK.

Just as I started to wash up, I heard Joyce screaming my name upstairs – I flew up, just as she came from hiding under the bed clothes – and rushed past me down the stairs.

No wonder she was frightened – anything small and throwable was being flung at her – books, glasses, shoes – anything – the bed was covered in things. As soon as she left the room and I went in – it stopped at once, everything was still. Nothing was thrown at me, and I realized that she was the one the ghost (or whatever it was) hated and was trying to drive her out.

She wanted to leave and we all talked about it that night, but the men were dead against it – Geoff said it would be mad to pay rent when they were living with us rent-free, just mucking in with the cost of food and things. They still thought we were exaggerating, I was exasperated, and I asked them to leave for work a bit later next day, just to see if anything happened in the morning.

After breakfast next morning, they hung about for a bit, but nothing happened – (I wondered whether the ghost knew they were still there) so they got fed-up, and decided they were off. They were just putting their coats on, when all hell broke out upstairs. I explained how their bedroom was just over the kitchen where we were, and suddenly there was a tremendous crash that shook the ceiling. Then more thumps and bangs followed in rapid succession – until the noise stopped as suddenly as it had begun, and silence reigned once more.

In that silence, Joyce looked at Barry and Geoff and said very quietly:

"There's your proof."

The men looked stunned, then made a bee-line for the stairs, Barry leading – the rest of us following.

He turned the knob to open the bedroom door – it opened a few inches then stuck. Barry gave us a puzzled look, then thrust his shoulder against the door, and after a few hefty shoves he managed to open it sufficiently to squeeze through, and we all followed.

It was apparent immediately why Barry had had such difficulty getting in. The double-bed sized mattress had somehow been transported across the room, reared up on end, and was wedged against the back of the door, so Barry knocked it flat and we all stood there in a huddle looking around the room.

It was in a state of absolute chaos.

The heavy wardrobe, which had taken all the strength of two moving men to put it in place, was now at the other end of the room, on its side.

Clothes, bedding, rugs, lay in a great twisted pyramid on the bare springs of the bed.

Once again pictures and ornaments had been thrown violently across the room and smashed.

It looked for all the world like one of those news pictures on TV of places that had been in the path of a hurricane.

The look on the faces of the two men showed they were convinced alright – we didn't need to say a word. So, once again, we set to work to tidy up the mess.

The disturbances went on daily, so to save a lot of damage and trouble, we moved all the small portable things out of the room, and just left the chest of drawers and wardrobe for the clothes.

We all began to realise that whatever or whoever was haunting, Joyce alone was the target of his hatred. He took no notice of me, our menfolk, or our children, who were completely unaware of what was going on, and we meant to keep it that way.

Nothing out of the ordinary ever happened when Joyce was out of the house, it was just when she was present that things would erupt.

The happenings were only confined to the bedroom, the rest of the house was peaceful, until one Sunday afternoon, when the kids were out, the men were in the sitting room reading the papers, and Joyce and I were in the kitchen, preparing tea.

I had just opened two tins of salmon, and tipped the fish into a basin, when suddenly one of the jagged edged lids rose into the air and started whizzing in circles around the kitchen, then it shot towards Joyce who tried to get out of the way.

She twisted her head sideways and it sliced the side of her neck, cutting it badly, if she hadn't dodged, it would have cut her throat.

Another time, my daughters were in the village carnival dressed as pirates, and their dad had made two wooden swords for them, not sharp of course.

I'd read somewhere that a cross would keep a ghost away, so one morning when we were once again tidying Joyce's bedroom I laid one on Joyce's pillow.

She was at the window unknotting the curtains and the sword rose up, shot across the room so fast it was almost a blur, and gave Joyce a painful blow on her back, which later came up as a bruise.

Poor Joyce was on the edge of a nervous breakdown by now, she was thin and pale and very jumpy. She had seen the ghost more than once in her bedroom and told me she was afraid to come home from work.'

Me: 'How long did she stay with you?'

Irene: 'Quite a few months.'

Me: 'Why on earth did she stay that long if she was so scared?'

Irene: 'She had nowhere else to go – there were four of them don't forget, and it took months to restore the cottage as the men could only work on it evenings and weekends.

Anyhow, now it had come down into the kitchen, things started to happen there too. If Joyce was having a meal with us, sometimes the pepper pot or the salt cellar would fly off the table and smash against the wall. Knives and forks would move across the table into a heap, or a plateful of food would turn upside down.

The worst thing that happened was early one morning when Geoff was fast asleep in bed. He used to wear a gold chain around his neck – and he woke up suddenly feeling as if he was being choked. He felt the chain was tightening around his neck, and he thought he was being strangled.

The chain went tighter and tighter – he was gasping for breath when suddenly it snapped and he was free.

He staggered out of bed gasping for air, and there before him, on the top of the wardrobe was a man's head glaring at him with its deep set eyes beneath a shock of black hair.

He couldn't get down stairs quick enough – telling us what had happened, and we could see the angry red mark on his neck.

We made him some strong tea, then when we all went up to the bedroom – (which was empty by now) we found the gold chain. It was in a neat little pile at the bottom of the bed on the carpet, and the weird thing was, every link was separated from its neighbour and every link was closed – so how had it been torn off?

Well, we all wanted to know who he was and why was he haunting us.'

Me: 'Did the children ever see him?'

Irene: 'Yes my girls did once, they were in bed and they woke up late one night and he was there, and he asked them in Welsh were they warm enough and when they said yes he told them to go back to sleep. The girls spoke Welsh because they had learned it at school.'

Me: 'Weren't they afraid?'

Irene: 'No they just thought he was a friend of their dad's who had come back from the pub with him. They didn't know about the hauntings, we didn't tell them until long after – when we had moved in fact'

Me: 'And did you see him?'

Irene: 'Yes, but only once – I'd told a medium about him, and the medium said – ask him what he wants, go up to the room he haunts, and ask him there.

So one afternoon, when I was alone in the house – I said to myself – come on Irene, it's now or never, what are you waiting for?

So I got up, marched through to the kitchen, and we had a sort of stable door at the bottom of the stairs, the sort of door which has a top and a bottom half, so I opened the top half, and there he was, standing at the bottom of the stairs, not a foot away – staring at me with those awful eyes.

Well, I forgot all about the medium – I just slammed the door closed on him and legged it back to the lounge.

It never stopped – in fact if anything it got worse. Joyce and I used to sit in the kitchen listening to him wreaking his daily havoc upstairs, waiting for the eerie silence that fell when he had stopped. Geoff saw the horrible head again on top of the wardrobe – every adult felt the uneasy atmosphere, and Joyce looked worse every day.

So we had a long talk one night sitting around the kitchen table. We didn't want to leave because we had paid for a long lease – but we were all unhappy, and we didn't know what to do, finally, we decided one of us should find out the whole story, and as I was the only one not working, I was appointed. I didn't like the idea, but as I hadn't got much choice, I agreed.

I started asking around about the history of the place from locals. No luck at first, then I got talking to an old man whose grandfather had been a stockman at the farm, and this is what he told me.

He said that many years ago (I worked out that it must have been after the first World War, as the ghost was wearing an old First World War uniform jacket – whether someone had given it him, or whether he was ex-army we don't know) a youngish man worked at the farm as a farmhand, along with a couple of others.

There was a shortage of jobs after the war and men had to take what they could get. Farm work was very hard, the farmhands were out in all sorts of weather, protective clothing had not been invented and the only protection against the cold driving rain and wind was usually an old sack pinned over the shoulders, with two more bound around the legs up to the knees, a shield against mud and puddles.

The only entertainment they had was the local pub, where a man could forget his dreary life for a few hours amongst his friends, with a big fire to warm himself by and

a few pints to bring a feeling of well-being, however transient it was, and this seems to have been the lifestyle of our ghost, when he was on earth.

Now to the one who became the ghost.

His name has been forgotten, but he has been remembered as a very hard worker and a very hard drinker.

Apparently, he was a truculent, hot-tempered man – he loved fighting and would throw a punch at anyone, at the slightest provocation. The only person who had control over him was the maid who lived in the house, he loved her dearly, with her he was as gentle as a lamb, and they planned to marry.

The maid's bedroom was the one Joyce now slept in. In those days, farmhands always slept in the outhouses, every farm had a loft with stone steps leading up to it, and each loft had primitive beds for the men, usually sacks filled with chaff or straw.

This particular outhouse was joined onto the main farmhouse at the rear, and an inside door led into the back quarters of the farm, which the men used to come in for meals and washing etc.

One cold wet winter, when the men worked day after day in the rain and never seemed to get dry, our man (let's call him Owen) caught a chill, and although he was tall and strong he developed a hacking cough and became very breathless.

On the maid's day off, when she went back home to see her family, he announced that he was going out with his mates to their local pub at Nebo, saying that a few tots of rum would put him right. Here I came up with a problem – there is no pub in Nebo and no one could remember having heard of one – it was a long time ago. I pondered it for quite a time, until I had a brainwave. In Pen-y-Sarn, on the hill to Nebo stands Tanrallt farm, and living there is Mrs Mary Owen. Now in her mid-nineties, she has a needle sharp brain, a very clear mind and a fantastic memory, so I phoned her.

Me: 'Mrs Owen, do you know the name of the pub at Nebo which has been closed for a very long time?'

Mrs Owen: 'Let me see Bunty bach, I did know it but can't recall it right now. Give me time to think, and I'll ring you back.'

She was as good as her word. An hour later the phone rang and she said triumphantly 'The Bull'.

'Oh great' I said, 'now I've got a name for it – thank you I'm delighted!'

Mrs Owen added: 'and there was another one in Pen-y-Sarn, not Y Bedol (The Horse Shoe) which is there now – and that was 'The Kings'.

(So thanks to Mrs Owen, these two pub names have been saved for posterity instead of sinking into oblivion and forgotten for all time.)

Back to the story.

So Owen and his mates trudged through the black, wet night up the hill to the Bull. They were soaked to the skin when they arrived, but a blazing fire greeted them, and Owen sat steaming in front of it, downing his tots of rum and feeling the warmth of the spirits easing the pain in his chest.

He ended up so drunk his friends had to half carry him back through the sleety darkness down to the farm.

It was a great tussle to shove Owen up the stone steps into the loft, where he immediately fell onto the floor in a drunken stupor. His friends were drunk and tired too, but together they dragged him to the sacks of chaff that was his bed, and tried to take off his sodden old army tunic.

He was wracked with coughing – but weak as he was, he cursed and swore and lashed out with fists and feet in a drunken fury – so they waited until he had passed out again, then they heaped lots of dry, sweet smelling hay around him to keep him warm.

Next morning he was dead.

That – such as it is stands, was the story. But it leaves many questions.

Who was he?

What happened to his sweetheart, the maid?

Did he resent Joyce for sleeping in the maid's bedroom?

Irene tells me that once Joyce had left to go to live in the cottage, she never went near the house again.

After Irene and Barry left (they were never troubled by the ghost again) the house was taken by a man and his wife, (whose names I will not divulge.)

The lady went to see Irene and asked her if she had ever heard noises at the farm, Irene told her the full story.

Then the pair parted, the wife left and the husband stayed in the house. For a time, he let out rooms to D.H.S.S. people, then he departed as well, and the house was unoccupied for a time. The last people to live there was a woman and her two children, they stayed about eighteen months, then left abruptly, no one knows where. So once again the house stands empty.

OR DOES IT?

STORY TWO

As far as is known, the only person to be attacked outside the house was Mr Les. Jones, who was on the road, a good five feet away from the boundary wall, and this is how it happened. I tell it in Les's own words.

'Years ago, I had been to my step-daughter's wedding, and some of my friends had come over for the occasion, and were staying in Bull Bay. So we had had a very convivial evening, with a few drinks of course, and I was walking back from Nebo, down the hill to Llys Dulas.

When I got level with the old empty farm, I suddenly remembered its reputation and I stopped and thought to myself

"Hmm, I wonder if there are such things as ghosts?"

I wasn't quite sure whether to believe it or not, and I thought – well I'll prove it tonight.

So I stood in the middle of the road, opposite the little side gate in the wall – you've seen it where the steps go up?

And I shouted out and asked him very politely to show himself, just to prove that he was there. Well, I stood and waited and nothing happened. So I called again and again, still very polite, and gradually I lost my temper and I began to swear and call him all sorts of names. It was a very dark night, I kept turning around to see if there was anything behind me. Not a thing. Just as I was shouting again something suddenly gripped me around my middle.

Not like a pair of hands, more like a steel band – so tight I couldn't move. Next thing I knew, I was lifted high into the air – and my arms and legs were flailing about, I was quite helpless, and then whatever it was that was holding me rushed me through the air to the wall at the side of the gate – and bashed my back against the wall so hard it

knocked all the breath out of my body, and my elbows and head hurt so much I nearly passed out. It did this twice, I felt as if my back was broken.

Then it lifted me even higher, my head must have about eight feet off the ground, and it bashed me down to the earth again twice, with all its might.

I hit the road with my feet, and I was tremendously jarred – my shins felt as if they had been forced up into my knees, and my teeth clashed together so hard I bit my tongue.

Then suddenly it let go, and I was staggering about all over the road, and when I got control of my legs, I set off down the hill at a rate of knots.

I banged on the door very hard with both fists "Let me in let me in, the ghost is chasing me," I yelled, making a tremendous racket.

When my wife opened up – I fell inside – slammed the door, and shot the bolt.

I hadn't used my key – didn't have time – I thought it had followed me you see, and I dropped into an armchair, very confused and aching all over.

Of course, my wife thought I was drunk – nothing I said would convince her but it was the truth, I would gladly swear on a stack of Bibles. Now I know there are such things as ghosts – that proved it to me, and now I'll believe in them for the rest of my life.

3
GHOST GEORGE

Mrs Jenny Acton told me this story on the phone. 'I can vouch for this one,' she said, and began her story.

I have a friend in Cemaes, Mrs Carmen Hughes, who lived in the High Street in Cemaes, she has a son Alex, about thirty, and I have one about the same age, they are good friends and have been like brothers all their lives.

When Alex, the eldest boy, was about seven years old the family had moved into a different house in the town. They had only been in the house for a few months when Alex started to complain about being tired. As he was a normal healthy child and was put to bed early enough, his parents couldn't understand why he was not sleeping.

When they questioned him, he began talking about a boy called George who was with him all the time and wouldn't let him sleep because he wanted to play. 'We thought at first that he had just made up an imaginary friend, like some kids do at that age.

But after a while, when they heard Alex talking to someone they couldn't see and nodding and smiling, they became more and more worried. So after some serious discussions, Carmen and her husband decided to approach a medium. They did this, and he made an appointment to visit the house.

When he arrived, he paused as Carmen shut the front door behind him, and stood silently, and almost like a bloodhound, his eyes roamed around, and his head tilted, listening and drawing deep breaths, like a hound scenting the air and atmosphere.

Carmen began to ask him if he would like a cup of tea, but he raised a finger for her to be silent as he went on building a sensory picture. Finally, looking upstairs, he said softly, 'The cause lies up there'.

Laying a hand on the banister, he slowly started to climb. He had only reached the second stair when he stopped, looking upwards for a long time. Then he turned to go down again. He beckoned them into the front room, where he indicated they should sit down, and they obeyed him in fascinated silence. Leaning forward with hands on knees, he said with great certainty, 'There is the spirit of a child in this house. It is a little boy, aged about seven in earthly years. When he was alive, he was called George. He is a very lovely child, and he has become very attached to your eldest son,' he paused and, looking at Carmen, said, 'I think you have a boy about seven?'

She nodded, speechless.

'Well, George has a lot of influence over him. I believe they hold conversations with each other, and you can only hear your son's side?'

Carmen nodded again, vigorously.

'Well, George has been here for years, and he regards your son as his special friend, and as long as you remain in this house, it will develop until the relationship is very hard to break.'

Seeing the horror in their faces, he raised a hand and said, 'Mind you, George wishes your son no harm, but the bond between them is very strong.'

Carmen looked troubled.

'But I don't know what to do – what *can* we do to put a stop to it?'

'I'm afraid there is nothing you can do my dear,' said the medium, 'short of leaving this house.'

Carmen and her husband looked at each other searchingly, then both nodded at the same time.

'We'll leave,' they said together.

And so they did.

Carmen did some research into the history of the house, and found that a boy of seven died of pneumonia in the 1850s. I wonder if the poor lonely little ghost is still there?

4

THE SINGING LAUNDRY MAID?

This story was given to me by Mr Ted Hughes, of Bryn Alaw, Anglesey.

'My son William,' said Mr Hughes, 'used to be with the National Trust, and a few years ago he was sent to work at a village in a bleak area of the Brecon Mountains.

He was planning officer then for the Brecon National Trust, and his job was to map out the sites of old buildings and churches. He loved it; he was an expert.

So one morning, the National Trust jeep dropped him off with his camera, plans and all the rest of his gear. His mission that day was to examine the ruins of an old mansion – Plas Erth it was called, or something like that. It was a very isolated spot in the hills, no houses or people for miles, just the cattle and the sheep.

When he arrived at the site, he found the roof had fallen in, and the whole place, while still standing, was in ruins. In its day, it had been a stately home, a very rich estate, but all the family had died out and it had been abandoned for years. He worked hard all morning then, at lunchtime, he took his sandwiches outside. The sun was warm, and all the birds were singing, there was a very slight breeze and the skies were blue. When he'd eaten his sandwiches and had a drink from his flask, he went back inside.

The morning had been used for taking measurements and making plans of the structure, so now he started work on the cellars. The time passed very quickly and he'd enjoyed the day.

About five o'clock he started to pack up his gear, as he had to walk about a mile downhill to where the jeep would pick him up on the road. As he came up from the cellars, and walked down the wide hall to where the massive front door had once stood, instead of looking out at green grass and blue sky, it looked as if someone had covered the doorway with a grey cloth.

The mountain mist had silently rolled down, suddenly and thickly, as it does in the hills. The bird song had stopped and everything was still and eerie in the blanketing fog.

He was walking away from the building, hitching his bag over his shoulder when, all of a sudden, he heard a woman singing in a clear and melodious voice.

William was very surprised at this, as it was miles away from any habitation, so he walked all around the ruin looking for the singer but, although the sound went on and on, seemingly quite near, he couldn't find anyone. He searched for a long time in the

mist, stopping now and again to listen, and becoming more and more puzzled, because there was nobody there but himself.

Eventually, the song died away in the distance, leaving utter silence. So he walked back down the hill to where the jeep had just arrived to pick him up, and as they drove back he told his friend about the unexplained happening.

'Oh Wil,' scoffed his friend 'you've been hearing the birds sing.'

'I can tell the difference between a bird singing and a woman,' said Wil, a bit annoyed. 'And it was definitely a woman singing.'

'Singing what?'

'I don't know what it was,' said Wil in a puzzled voice, 'But it was' – he stopped and sought in his mind for an example. 'It was a happy work song, you know, the kind a woman sings when she has finished her washing and she's hanging it out on a sunny day – that sort of singing.'

When he got home, he told me the story and I asked him to sing it for me, but Wil doesn't take after me, if I hear a song once, I remember it and I can sing it, but not Wil, he sings like a jackdaw.

He did say he thought it was old, perhaps in the era of 'The Ash Grove', that sort of song. So I had to be content with that, until one night on TV, a girl was singing in Welsh, accompanied by her harp, and all of a sudden, Wil leaned forward, pointing at the set, and said excitedly 'That's the song Dad, that's the song!'

It was 'Farewell I Langyfelach Lon, I'm going to join the Duke of York'. So it dated sometime in the Napoleonic Wars, between 1800-1815. Wil was very interested because he couldn't understand who he had heard singing, as he thought he was the only person for miles around when he heard it.

He wanted to find out as much as he could about the property, so at the first opportunity he went to the nearest village to the ruined mansion to find someone to ask. It was no good asking the younger generation, so he was very glad when he saw an old man, shuffling along with a walking stick. He enquired about the house and politely asked the old man whether he knew anything about it.

The old man listened carefully, one hand cupping his ear, and when Wil told him the mansion was called Plas Erth, he nodded happily and said with a toothless grin 'Oh yes, my grandmother used to work there, there's a ghost there you know – and she sings!'

And Wil was dumbstruck – this was the first time he had ever considered his singer to be a ghost!

5
LLANGEFNI RECTORY

After writing enough pages of notes for a book devoted wholly to the Rectory, I have found that the ghosts it undoubtedly houses are still as nebulous and mysterious as they were when I fruitlessly embarked on trying to establish their identities many months ago.

Llangefni church, to which the rectory belongs, has been there in one form or another for nearly two thousand years.

Before that, it was a very holy pagan site, complete with the well which nearly always accompanied these places, as the water gods were venerated as very powerful beings.

Christianity came and incorporated the pagan festivals into festivals of their own, until the Christian belief transcended all others.

So the church building itself was built and rebuilt over the ages, until finally, the wealthy, well-meaning Georgian and Victorian vandals tore down centuries of history and replaced most of the church with the handsome stone structure we see today. The Rectory too underwent changes and became a grand nine-bedroom spacious dwelling, needed in Victorian times to entertain and house successive visiting bishops and their large entourages.

But however the structures changed, the original ghosts that dwelled there remained, and although there are a number of them, their origins remain unknown, who they were and in which century they lived.

All except one, and the oral stories of her brief life in the nineteenth century have been handed down the years, and what I needed was proof.

Mr Michael Bayley-Hughes (whose late father was the rector of Llangefni), and his friend Mr Tomos Roberts (retired senior archivist, Bangor University) both kindly worked diligently to provide me with it. Mr Roberts tirelessly went through the archives and church records and Mr Bayley-Hughes going with him, finally, to the graveyard and the grave where she is buried. They sent me a photograph of the gravestone, illustrated in this book.

So here is the story:

In the late winter of 1832, a cold February day, dusk was falling quickly around Llangefni Rectory and young Ann Jones was performing her daily task of lighting all the lamps, and placing them in the downstairs rooms before drawing the heavy curtains,

replenishing the fires and making the rooms warm and cosy, shutting out the bleak winter's night.

She bustled into the small room by the kitchen where the lamps and oil were kept, no doubt thinking of her young husband (she hadn't been married long) and quite unaware of the horror to come.

Ann filled the lamps, trimmed the wicks and lit them. The first lamp with its beautiful rose coloured glass was always placed in the drawing room and she picked it up, turned to carry it out, and suddenly tripped and fell with the full heavy lamp in her hands.

It shattered beneath her and the lamp oil splashed all over her, soaking her heavy Victorian clothes and bursting into flame.

She screamed in pain but when others heard her and rushed in, she was a human torch, everything about her on fire, even her hair, and within seconds she was beyond help, and died an agonising death.

Ann still haunts the Rectory, sometimes visible as a frail little figure who is seen silently moving around the small lamp room, or her dying shrieks are occasionally heard echoing along the corridors of the Rectory late on a February evening.

She was buried within two days and her gravestone was placed there by her employers, the Rev. and Mrs Williams, who were in residence at the rectory at the time of the maid's death, and could have witnessed her horrifying end.

The gravestone of Ann Jones, the ghost maid at the rectory. (Photo courtesy of Tomos Jones)

Mr Michael Bayley-Hughes never saw or heard anything untoward at the Rectory, neither did his mother, although she did say that people in the town said it was haunted.

Michael's father went into the church one day and found that many of the contents had been defiled and desecrated, prayer books torn and scattered, the Bible mutilated and traces of blood on the floor. It was very obvious that Satanists had held a mass there, but the Rev. Bayley-Hughes never spoke of it. It was only years later that Michael heard of it from his mother.

When the last incumbent rector left for Caernarvon, another phase of history began for the rectory. The building, being too large and costly, was put up for auction by the diocese.

It was then bought by a retired miner from Derbyshire, and he and his wife, daughter-in-law and son prepared to move in.

By this time the building, having been empty for a few years, was in a state of disrepair.

Now Roger Benn, who bought the rectory, takes up the story.

'When my son and I first inspected the place, it was by torchlight, because the windows had been boarded up.

It had a sophisticated burglar alarm installed by the diocese, touch buttons in every room and pressure points on the stair pads, which had all been vandalised. The control systems had been ripped out, the Georgian banister was gone, as were all the radiators and pipes and the cooker etc., anything of saleable value had been taken.

The roof also was new, but all the lead had been stolen and some of the guttering had been broken. Fortunately, the windows, which had been double-glazed, were still intact.'

There was a lot to be done, and Roger's son Gary, who was head of the drugs squad in Leicester and is now with the Bangor police, told his father that it looked as though it had been used as a 'crash pad' by druggies and vagrants, and had all the signs that it still was.

The Benns had to live in a caravan in the grounds, and they erected a high fence around the rectory, because the 'druggies' returned quite frequently whilst the renovations were in progress. They had two bearded collie dogs, Sheba and Cheney, who had ferocious barks (even though they were as soft as rabbits) and were a great help in deterring unwanted visitors.

One of the bearded collies was at first very reluctant to go inside the Rectory. She turned and fled with her tail between her legs, Susan said later that it happened many times when Roger wasn't there, but she gradually got used to it, because as Roger said, the atmosphere was very happy and peaceful, nothing to be scared about. All the time they lived there, the dogs seemed to see things that the humans couldn't, staring into corners or following with their eyes something crossing the room, that the Benns never saw.

Whilst the Benns were living in the caravan, Susan was taken ill and they had to move into the house whether it was finished or not.

Susan told me on the phone:

'When we had been in the house for a few nights, I woke up and saw a man standing near the bedroom door. He walked over to the bed, stood and looked down at me for a moment, then walked around the bed to Roger's side, and looked at him. Then he moved across the room to the door, and just seemed to vanish.'

I asked Susan for his description, and after a moment's thought she said:

'Well, he wore a green tunic – I could see it in the reflection of the street lights through the window, it was buttoned all the way up, and green sort of leggings. I don't know whether it was an army uniform or some sort of livery. No hat, and his hair was long, below his ears. He was in his mid-thirties I should think, and was very pleasant to look at – he didn't pose any threat at all.

I knew he wasn't a living person – a ghost in fact, but he was like the house, gave off very pleasant "vibes", there was nothing frightening at all.

Other times, he just came from the direction of the door, looked down at me, and walked back.

When the Rectory was finished, my son and daughter-in-law came to live with us, and before they arrived, we decorated our bedroom for them, and we moved out of that room, so that they could move in.

They had been with us for about three months, when my daughter-in-law, Lynda, came to me and said:

"Don't think I'm going mad, but every night a man comes into the bedroom and stands looking down at me."

"No Lynda, you're not going mad, I saw him too – are you afraid?"

"Oh no," she said, "he's not a bit frightening, he feels peaceful."

She seemed quite happy about it. Then she became pregnant and had problems sleeping. It was as if the ghost knew, and every night he would stroke her from the top of her brow to the tip of her nose and she would slip into sleep straight away. Do you know (Susan said) when Lynda's twins were born, if they wouldn't sleep, she automatically stroked them in the same way, and they too fell asleep.

He didn't leave her – sometimes in other parts of the house she felt him touch her lightly on the shoulder, or briefly take her arm.

Just about that time, Lynda and I had a very strange experience – this was outside the house, at Lidl's, the supermarket in Llangefni.

The babies were just new born. Identical twin boys as alike as two peas in a pod. Nobody could tell which was which, not even me, and I'm their grandmother.

They were in their new twin pushchair, and we had just got to the door when a man appeared.

He was black, not brown or anything – black. He was very tall, very handsome and dressed immaculately in what we took to be a security uniform.

He walked towards us and looked down at the twins with a lovely smile. Then he knelt down, just in front of them and made the sign of the cross on both their foreheads, and he said "Luke and Isaac".

He looked at Isaac and said "Isaac's going to be strong." He said something else that I didn't catch, then he turned to Luke and said "Luke is going to be ..."

We didn't hear what he said because we were so gob-smacked – it didn't sink in, because he said Isaac and Luke, he got it right, and nobody, but nobody, can tell which is which.

Then he smiled at us, walked around the pram and went.

"Who was that?" Lynda said, staring at me.

I couldn't speak, I just shook my head, and we both turned the pram around and hurried after him, but we couldn't find him, so we walked all around the car park, but he wasn't there.

Llangefni Rectory. (Photo courtesy of R. Benn)

So we went in and looked all over the store for him, and I said to the girl on the checkout "I didn't know you had security men," and she said, "We don't dear".

So I said, "Well, there's a security man on today, is it something special?"

She looked at me as if I was a bit dim, and she said, "No, we never have security men."

Later, I asked a girl I worked with, who used to work at Lidl's, "Do Lidl's have security men?"

"No," she said, "they don't even have floor walkers or security cameras."

So it has stayed a mystery.

When Roger and I were going away, it meant Lynda would be on her own, as her husband hadn't been transferred to Holyhead police then, and I always asked her if she was afraid to be alone, but she said no, she always felt safe with them all around her.

Another thing, we have a little grand-daughter who is a Downs Syndrome child, and once she came to stay and we put her to bed and we could hear her chattering and laughing for ages after she had been laid down.

When her mother went in to tell her to go to sleep, the little girl said "Not yet, Mummy, I want to talk to this lady."

"Which lady?" asked her mum.

"That lady sitting on Grandma's bed," said the child, pointing to the empty bed.

Even though weird things like that happened, it was a very happy house – there was a room at the end of the corridor that we used to call "the annexe". It was a most peaceful, tranquil room, and when I had a migraine, I used to go and lie in there, and gradually the pain would go. Lynda did the same and said she felt enveloped in comfort.'

Susan told me that they sold the Vicarage about four years ago. They hadn't said anything to the new residents about the ghosts in case they didn't buy.

I asked Susan if anything had happened to them, apparently it had. The new lady was called Hilary and she made friends with Lynda and Gary (Susan's son and daughter-in-law), and then went to visit them. One day she went to see them, looking very thoughtful. She said, 'I want to ask you a question. While you two lived at the rectory, did anything strange happen – I mean is it haunted?' It took them by surprise, then Gary said 'No' and Lynda said 'Yes!'

Hilary told them that why she had asked was because her married daughter had come over from America to stay with them, and went to sleep in the annexe.

She said that in the night the door had opened, and a woman said distinctly, 'Oh, it's you!'

That was all that was said, but it happened again and again. This was a puzzle, but Susan wondered if it was the same lady her little grand daughter saw on the bed.

'We all saw *something* – even my husband Roger (who doesn't believe in ghosts) saw one – it was like this:

One night he was snoring so much I got up and went into the spare room. Apparently, he woke up and saw a woman walking around the bedroom. At first he thought it was me, but when she walked right through the wall and he found my side of the bed empty, it gave him a great shock. When he told me next day, he said he must have been dreaming. I could tell he didn't believe that because he was so quiet and thoughtful all day – he's always said he is a non-believer but that really shook him!'

The fact that Roger said he was a non-believer made me want to find out more about his side of things, so we had a lengthy (taped) phone conversation, which was most interesting.

The puzzle of the sophisticated alarm system, which made Roger wonder whether the last rector had been haunted, was explained by further research.

My good friend, Michael Bayley-Hughes, put me on to the track of the Rev. Geoffrey Hughes, who lived at the rectory before it was sold. He very kindly informed me that he had a lot of valuable antique furniture (passed down by his family) and his insurance company insisted that it should be well covered, so the diocese had installed the system.

That was one problem solved, and I took the opportunity of asking him whether anything had happened whilst he lived there. He remarked wryly that the ancient coach house had collapsed whilst they were having lunch one day, and apart from that, they had a colony of bats living in the roof of the rectory at one end, and a swarm of bees living happily at the other. Nothing supernatural about that.

I explained this to Roger, clearing up a point for him, and when I asked him casually (knowing his reluctance to talk about the supernatural) if anything else had occurred besides seeing the lady, he surprised me with these stories.

'Well, we worked hard on the house, we decorated, painted and sanded the floors.

We had a beautiful lounge, and one summer's evening we were in there reading, when Susan asked me if I would like a cup of tea and a piece of cake. She brought the cake first and said the tea was just brewing. I ate the cake, drank the tea when she brought it in, and put the empty mug on the plate. We sat watching television then, and the room was quite still and peaceful, when suddenly we heard a loud ringing noise, and as we

both looked around, we saw the empty cup was going round and round on the plate. Susan couldn't believe it, but I thought at first it was a bubble of water – you know how sometimes they get trapped under the cup? But it never stopped, just kept circling around the plate for ages, so I picked it up, it was quite dry, no bubble, and when I put it back it stopped.

Another night, calm and no wind, we heard a sudden rustling noise in the back corner of the lounge, nowhere near a window or a door. We had a big plant there, I've forgotten what it was, but it had a lot of bushy leaves on, and they suddenly started thrashing about like mad – you know how palm trees go on TV in a hurricane? Waving from side to side? Well, just like that, as if they were in a high wind, and it couldn't have been more still in the lounge. It went on for two or three minutes – then it just stopped dead.

There was something else too. Our daughter-in-law, Lyn, lived in the big lounge on the other side of the house, and one night Susan and I were sitting in our lounge when all of a sudden a little clicking noise started, and it went on and on, click-click, click-click. We couldn't figure out where it was coming from at first, then we saw the porcelain knob on the door going round and round.

"That's Lyn, bringing us a cup of tea," I said, getting up, "perhaps she can't open the door."

So I went to it, opened it and looked out – the hall was empty. Lyn was in her own lounge watching TV!'

I listened to Roger's stories with great interest, and wondered whether after all these happenings, he was still a non-believer, but I couldn't bring myself to ask.

I can now though. 'Are you, Roger?'

6
THE WELL-DRESSED GHOST

Mr Idwel Owen, once a very popular butcher in Amlwch well known for his high quality meat and cheerful manner, was a very busy man, having also been president of the Bull Bay Golf Club for twenty-nine years. Now, however, he spends his spare time playing his beloved Welsh harp and lives with his attractive wife Doris.

He kindly recounted these stories of things that had happened to him years ago.

During the war years, he was coming home on leave from Greenford and, as usual in wartime, the train was late. Instead of arriving at 10.20 pm at Bangor, it drew into the station at 11.30 pm, which meant he had missed the last bus to Anglesey by about an hour. There was no other choice but to walk, and it's a heck of a long way from Bangor to Amlwch.

He had only gone a couple of miles on the mainland when a van pulled up at his side, and the driver offered him a lift, saying he was going to Llangefni, the county town of Anglesey. It's still a marathon hike from there (Llangefni is in the centre of the Island, Amlwch is on the north-east coast) but it was much nearer than Bangor and at least he would be on the Island.

He accepted gratefully and climbed in, noting there was a coffin in the van, but as the driver didn't give an explanation, Idwel thought no more of it. Eventually they reached Llangefni, Idwel thanked the driver and climbed out, then turned and set off on his lonely journey of approximately twelve miles. It was a cold clear night with a full moon, and Idwel trudged doggedly along, until weary and tired, he reached the outskirts of Amlwch.

The roofs gleamed silver in the frosty moonlight, and it was now about 3 am with all the good citizens of the town snug and warm in their beds, and the streets which were bustling by day, were now completely empty, and devoid of movement.

Ah, but not quite. Idwel stared hard.

Coming along steadily towards him was a woman. He was amazed to see anyone and wondered who it was, but as she came out of the shadow of the Wesleyan Chapel into the moonlight he was able to recognise her. It was Mrs Hope, well known and well liked in Amlwch, and the wife of the local police sergeant.

He stopped as she drew nearer and noted with approval that she was wearing her fur coat, needed on that winter night.

'Hello Mrs Hope,' he said, 'what on earth are you doing out at this time of night? You should be at home in bed.'

She was drawing closer, but never answered him.

'Glad you've got a warm coat on, it's a dam' cold night.'

She was only arm's length away by now, but still didn't reply.

'I've just walked from Llangefni, Duw, am I tired, hope you haven't got very far to go?'

Without seeming nosey, Idwel was trying to find out where Mrs Hope was going and what was so urgent that she should be walking abroad in the wee small hours. But the lady didn't say a word, she carried on walking past Idwel as if he wasn't there, she didn't even look at him, but kept her gaze fixed on some point ahead. Poor Idwel was dismayed at this, he had known her for years and never before had they met in the street without a friendly greeting. Mrs Hope swept past without a look or recognition, leaving him standing there.

Puzzled, he turned to watch her walk up the road, and it was only then that he realized that her shoes made no sound on the hard road, and she left no shadow in the bright moonlight, even though his own stretched across the street. He got home soon after and knocked loudly to wake up his wife Doris who was delighted to see him.

Sinking gratefully into his armchair, he chatted as Doris made him a welcome cup of tea, and he told her the bit of news that was uppermost in his mind.

'Do you know Doris, who I've just seen as I was passing the Wesleyan Chapel?'

'Surely nobody was out now? It's the middle of the night,' Doris said, busily pouring boiling water into the teapot.

'Was it a poacher?'

'No, nothing like one,' Idwel replied, stretching out his shoeless feet to the replenished fire. 'It was Mrs Hope, in her fur coat. Heaven knows where she was going, but when I spoke to her, she just ignored me, went past as if she hadn't seen me.'

Doris almost dropped the teapot, and using both hands, carefully put it on the table, then she turned with wide eyes and said slowly to Idwel, 'Mrs Hope is dead, she was buried last Monday and I went to the funeral.'

They stared at each other in stunned silence.

THE AMLWCH POLTERGEIST

Opposite Mr Owen's butchers shop was a very popular little cafe, called Sefton Café.

One Sunday morning, Idwel went to his shop as usual to see if his fridges were still working and everything ready for his Monday morning opening.

As he was locking up again, he was called by one of the girls from the café, and he strolled across the road to see what she wanted.

'Come upstairs, Idwel, she said. 'I've got something to show you.' Upstairs was the room where the girls did all their cake and pie baking for the café, and Idwel followed her. She flung open the door at the top and in the room stood the other three girls who worked there, looking nervous and huddled in a close group for support.

'Look there,' said the one who had called Idwel in, and pointed dramatically to one of the two long unvarnished dressers which ran along both sides of the room. Idwel looked around, everything was in apple pie order, the stove was gleaming, and neatly stacked along one of the dressers was a row of pasty boards, rolling pins, basins, cake and pie tins and everything needed in a small bakery.

'What's wrong?' asked Idwel, 'everything looks alright to me.'

'Oh, it looks alright,' said the girl, 'but that side is where we roll the pastry and mix the fillings, it is always kept bare and scrubbed each night before we go home, so it will be clean and dry ready for next day. We stack all that stuff,' she nodded at the kitchen utensils, 'on the other side, we did the same last night, they were all stacked as usual on that side, but someone or something moved them across in the night in exactly the same order, absolutely nothing out of place.'

She stared in bewilderment at Idwel, 'nobody, but nobody could have got in, the door was still locked when we got here, and everything was in order, so who could do it and why?'

Idwel couldn't answer.

Idwel said, 'I was delivering meat one Friday night in winter to customers around the countryside, and my last call was to a relation of mine who lived at Ty Wdwal, Llanruddall, a Mr & Mrs Hughes. I delivered the joint, had a quick chat with them, and explained that I was in a hurry because I had to pick up some bedding straw from a farm on the way back. The lane to their house was very narrow, there was no room at the end to turn when I left, I had to reverse back about fifty yards to a gateway into a field, where I turned round. As I turned out of the gateway and put the nose of the van back up the lane, I was suddenly stopped.

There, dumped right in front of me, spreading right across the lane and completely blocking it, was a great mountain of straw. I stared for a minute and pipped my horn, but there wasn't a soul about, so I left my headlights on and got out to see what I could do. I went to each side of it, but it overflowed into the fields and my van was trapped.

I couldn't imagine how it had got there, it must have been dumped in the few minutes I had been at Mr Hughes house. There was nothing for it but to shift it myself, so I muttered a bit, then bent down to move it out of the way in big armfuls. It took me ages to make a rough track through the middle, and when I got in and slowly edged forwards the straw each side was higher than the van.

Finally, I got through, put the brakes on and switched off. I went back to the great heap, which was in an untidy mess now, bits of straw all over the place, blowing in the wind. I called once or twice, but there was no sound, so I thought to myself, that's prime straw Idwel, and it's caused you a lot of time and trouble, and as nobody seems to want it, why not help yourself? It'll do fine for your pigs. So I opened the back doors of the van and loaded it up with the straw. There was such a mountain of it, even though I took a full van-load, it didn't seem to make much difference.

Anyway, I went back home, carried all the straw into the pigsties, and very comfortable and warm they were in it, good deep straw to sleep in.

Next morning, the shop was very busy but when I had a minute I phoned Mr Hughes to ask him who had left the straw there.

He was very puzzled 'What straw are you talking about Idwel?'

'The great load someone dumped in your lane last night'

He didn't seem to understand so I explained how I had to move it to get out and I'd helped myself to a vanload for the pigs. There was silence at his end, then he said, 'Is this some sort of a joke Idwel? If not you must be seeing things, I've walked all the way up the lane this morning, and back, and there's nothing there – no straw anywhere, not a stalk, it's quite clear.'

Well, we talked about it – me insisting that the straw had been dumped there and he insisting that there wasn't a wisp of straw anywhere, and all the fields, which were pasture on each side of the lane, were empty.

'Well, Idwel, I think you must have imagined it,' he ended.

When we hung up, an awful thought hit me – if the straw had vanished, maybe my pigs had vanished too! I left my assistant to look after the shop and drove hell for leather back home, very worried. But there they were as large as life, snoring or rootling in the fine, deep straw. Did I give a big sigh of relief! So ended the story of the straw, and it has never been explained since.

Thinking about it, and Idwel's story about the poltergeist in the café, I wonder if one had heard him tell Mr Hughes that he was going for straw for his pigs and had kindly brought a load for him? Also, somewhere, was there a farmer equally puzzled by the mysterious disappearance of his own good quality straw?

IAN JONES

In the 1970s Mr Jones, then a youth of about eighteen, was gazing from the bedroom window of a flat in Amlwch (Anglesey) when he saw the figure of a man moving along the road below him. The man was dressed in a long, full, topcoat and a round hat with a broad brim. Ian couldn't see his shoes, as the coat was so long and dark grey in colour.

Not only was his outfit unusual, he was not walking along the street, but 'floating' in a very smooth motion. He was moving in the direction of the main road – past the old cinema (now demolished), past the building where the old post vans used to park and turned the corner, going behind what is now the chip shop.

Ian's mother, in those days, worked in Sefton's shop, and they lived in the flat above the shop and it was from this flat in Maddyn Road that he had the sighting of the ghost. Strangely enough, said Ian, about five years ago, a colleague of his rented the flat and his wife saw the ghost of a man in her kitchen. It happened more than once and she was so shocked and frightened that she wouldn't stay there any longer, so they moved house.

Strangely enough, the Sefton shop, which later became the Sefton Café, was the very place Mr Idwel Jones was called to by the girls on the staff who had discovered their baking tins etc, had been moved from one side of the room to the other, during the hours of darkness between Saturday and Sunday morning. It was also the same room that Ian's friend's wife had seen the ghost of a man. When I asked Ian what his reaction was to seeing the ghost drifting up the road – was it fright? he just said, 'No, I thought my God! What's that? It wasn't human, you know how something is wrong – the way they drift along? I'd no sooner thought that than it disappeared around the back of the Queen's Arms.'

Ian also told me that there is a ghost dog in Amlwch which trots along Maddyn Road dragging a chain that makes a loud clinking noise before it disappears at the end of the road.

This story was told to him by his grandfather when Ian was a young boy, which makes the apparition at least a hundred years old, as he was told it by his grandfather, but it isn't the sort of ghost which fades out in the passage of time, as it is still frequently seen approaching the Bryn Og (home for the old people) and may have belonged to the farm which was demolished to make the old folks' home.

7

THE GHOST ROAD
(LON BWGAN)

Given to me by Michael Bayley Hughes.

Anyone traveling along the road from Pentraeth to Talwrn will have seen an overgrown trackway which in Welsh is called 'Lon Drol' or cart road, built by the Romans, once a busy thoroughfare, but now only used by locals.

Strolling along it on a summers day, gazing down at the blue sea glimmering off Red Wharf Bay, or up at Mynydd Llwydiarth, one would have to be psychic to realize that this pleasant spot is the scene of a bad haunting.

Lying back amongst the trees is a big very old house, Plas Llanddyfran, which during the Civil War belonged to Lord Griffiths. His was a prosperous gentleman's estate, his tenants were comfortable and content, and he was liked and respected.

In those troubled times, political loyalties were well hidden, Lord Griffiths and his family and tenants were Royalists, but this fact was not mooted abroad, as the savage Parliamentarian soldiers would have killed the people, and destroyed their houses, if they were known to be active Royalists. He was left in peace, therefore, but his illegitimate son Huw was young and hot-headed, and had left home to join the Kings army as an officer. Fearless and daring, he had fought many battles on the mainland, and in Anglesey, where his local knowledge was invaluable. He had a price on his head. At the time of the tragedy, he was known to be on the Island, in the Llanbedrgoch area, and Cromwell's soldiers knew this.

Nevertheless, although the house was watched, Huw decided to go and see his father, even though the district was crawling with bands of enemy soldiers.

He had a plan which was known only by his second in command and the trooper who looked after his horse. One evening when they had made camp, he quietly slipped away whilst his weary soldiers were having their supper, and made himself known to the sentry who was standing alert in the dusk, then mounted and faded away into the twilight.

Plodding along the well-known road, he listened carefully for any alien noises brought to him on the night wind. When he reached home and burst into the hall, his father rose from the settle by the fire, his face a mixture of delight, amazement and anxiety. He clasped his son in a warm embrace.

'Huw, Huw,' was all he could say in a choked voice. 'What are you doing here? Cromwell's men were here just yesterday – demanding to know where you were.'

'Father. It's so good to see you,' grinned Huw, slapping him heartily on the back. 'Send for some food, I'm starving – then I'll tell you all my news while I eat.'

Still smiling Huw kicked off his high riding boots and, grabbing his father's tankard of ale from the mantel shelf, he sank down onto the settle and stretched out his feet to the fire.

Food was shouted for and came. The servants were all agog to see him, and many unnecessary visits were made for his well-being – logs for the fire, ale for his mug, and more food than he could eat. He greeted them all by name, asking after their families, and joking merrily – seemingly uncaring of the danger he was in.

Huw and his father talked long into the night, giving each other details of how the fighting was progressing locally. They both agreed that the Parliamentarians seemed to be winning temporarily.

Finally, wearied with battle and stuffed with good food, Huw fell asleep, but not before he had given instructions to be wakened at daybreak, and made sure that one of the young men was on the gate as sentry. After a few hours deep sleep, Huw was rudely awakened by this same young man who, shaking him awake, said, 'Master Huw, Master Huw! Wake up – I have heard horsemen!'

Huw, instantly alert, sat up. 'Who were they? Which way did they go?'

Even as he was asking, he was pulling on his high boots, and reaching for his swordbelt.

'Troops were they? How many?'

I know not,' the man said, 'but I saw swords glinting in the starlight, and they spoke in whispers – uncouth men by their sound and smell – Cromwell's men like as not, and making for the Llanbedroch road.'

'Damn!' swore Huw 'they're looking for me – quietly now – help me to saddle up.'

Silent and swift, they saddled up Huw's horse who they found fast asleep. Huw mounted and whispering to the servant, told him to tell his father not to worry and to say goodbye.

Knowing all the countryside around since childhood, Huw chose a route that would take him around the marauding troops and back to his own men.

As the sun rose, Cromwell's men, not knowing the district, had stopped at a small cottage, Plas Bach, which, unknown to them, stood not far from Lord Griffiths home. They had come this far after being told by a smallholder with Parliamentarian leanings, that he had seen young Huw and his men in the district. They took a chance on him going to see his father, and they were combing the area.

Plas Bach was small, neat and one storied, with a tidy vegetable garden, a few fruit trees and hens scratching about the yard.

The sergeant dismounted, and rapped smartly at the door whilst the rest looked keenly about them. The door was opened by a young woman with a baby in her arms, and the beginnings of a smile of welcome, but when she saw the men and took in their uniforms, the smile died and her eyes widened in fear. She made as if to slam the door, but he easily thrust it open, and strode in, followed by the rest.

'Drink – woman, and hurry!'

The terrified girl quickly laid the baby down on a settle, and hurried to the dairy, returning with a large jug of milk and pewter tankards.

They drank greedily, and she hurried to refill the jug, her hands shaking so much the milk sloshed onto the floor.

Lŏn Bwgan (Ghost Road). (Photo courtesy of Walt Austin)

'Where is Plas Llanddyfran?' demanded the sergeant.

She gave them hurried directions, and he nodded curtly, and started to leave.

Without a word of thanks, the last one to leave banged his mug on the table, and followed his companions. As he passed the girl, he grabbed her long hair, pulling back her head, and exposing her throat.

'Hmm,' he muttered, 'pretty thing, but we're in a hurry.'

The girl stood frozen with fear, and, casually, he took out his dagger and expertly swept it across her throat. Then, grinning at the others, he let go of the girl, and swaggered out, leaving her lying in a widening pink pool of blood and milk. Completely unconcerned about the wailing baby and its dying mother, they rode away.

At this time, young Huw had left Plas Llanddyfran and was leading his horse silently away as dawn broke, only mounting when he could be sure that no one in the vicinity would see him, incriminating his father by his presence.

Luck was not with him still, as he turned onto the road called 'Lon Drol' (cart road) he heard a yell behind him and looked over his shoulder at Plas Bach. To his horror, he saw a bunch of tough looking Cromwellians spurring their horses to a furious gallop in hot pursuit of the young cavalier.

His drowsy horse was only walking, and by the time he had urged it into a surprised gallop they were close behind. Desperately, he spurred his horse down Lon Drol, but he had scarcely gone half way when they were upon him, and as they surrounded the hapless rider, one drew his sword, swinging it at his head, but the sword sliced off his ear, and bit deep into his shoulder.

Unseated, Huw fell from the saddle with a scream of pain, whilst his startled horse thundered away down the road. With yells of triumph the soldiers jumped down, drawing their swords, and fell upon the hapless youth. He tried to get up, making it to his knees before a vicious slash to his back made him fall prone.

Then they were all upon him, stabbing and slashing without mercy. His screams of pain echoed on the morning air, but they went on, grunting with the effort of their blows, until Huw was just a mass of bloody flesh on the ground.

But that wasn't the end.

Two months later, when the sad story of Huw's murder had been superseded by other war horrors, a local shepherd, one John Hughes, was going along the lane to collect his sheep, when suddenly he heard a terrific din which set up all about him.

There was a great shouting and jeering of men, the loud clash of swords, and the confused stamping of hooves. But the sound that made his blood run cold was the screaming of a man in mortal pain.

It was all happening around him, the din sounding inches away *but the lane was completely empty*. Suddenly the sound was cut off in the middle of a dying, choking scream and then silence.

John took to his heels, and ran all the way back home – his terrified dog had got there before him, and was cowering and shivering against the back door.

Word got around, some believed his story, others scoffed. That was the first manifestation, but by no means the last.

Other people have heard the same ghastly sounds, some have seen the dreadful fight re-enacted, but the strange thing is, it is not always re-enacted at the same time of day, or even on the anniversary of Huw's murder.

It will suddenly start with the noise, clamour and screams of a violent fight – then after a couple of minutes shut off abruptly, leaving the blood curdling sounds echoing forever in the ears of the horrified traveller.

It still goes on, as stated in a letter of Victorian times, by a lady who had estates on Anglesey. She writes that when she was a child of six, her father had ridden down the lane for a brief visit with his neighbour, Mrs Lewis. He had not arrived back home by lunchtime, so they sent out to look for him, and he was found on the ground insensible. His horse a fine hunter, was standing trembling beside him.

'My father' she states, 'for three days after, spoke and wrote in an unknown tongue. My daughters also, five years ago, were driving a stout pony in a basket carriage, and at the same spot where my father had been found, the pony stopped, trembling, was greatly distressed, then fell in a fit, as if shot.'

Many tales of such occurrences are told of happenings at this spot.

Not for nothing is this lane known as 'Lon Bwgan' or 'Haunted Lane'.

My thanks also go to Mr John Roberts Bryn Teg, and Mr Tomos Roberts (Senior Archivist, Bangor University (Retired) for kindly furnishing me with additional details. When we were looking for Lon Bwgan, a very courteous gentleman named Albert Owen (Cae Cynnd) escorted us all the way – leading in his car – because, in spite of Walt's exceptional sense of direction, we might have been lost forever in those beautiful winding lanes, never to be seen again.

8

THE JEALOUS GHOST DOG

Mrs Joyce Wilson of Dwyran Anglesey is a dog trainer par excellence. She had once acquired a German Shepherd bitch called Troy, a gentle and affectionate animal who always slept alone downstairs, as she didn't like the staircase which was open plan and made her nervous.

When Troy was five years old, Mrs Wilson was shocked awake in the middle of the night by a tremendous crash of furniture. She flew downstairs, everything was still and peaceful until she opened the door and switched on the light of the room in which Troy slept.

A large heavy chair had been knocked over and Troy was cowering in a corner, and staring fearfully at something Mrs Wilson could not see. As soon as she saw Mrs Wilson, Troy shot past her and streaked up the stairs, something she had never done before.

Mrs Wilson righted the chair, looked in all the downstairs rooms, then went back to Troy who had raced into her bedroom and now crouched trembling at the side of the bed furthest away from the door.

It took Mrs Wilson all night to pacify the terrified dog. There was no story of the house being haunted and Mrs Wilson was at a loss to know what had frightened poor Troy so badly.

One of Mrs Wilson's friends is a healer called Elizabeth, living then at Colwyn Bay, and when she heard the story she offered to come and visit to 'feel' the atmosphere.

After going around the house and into the room which Troy steadily refused even to enter, she told Mrs Wilson that she had the answer.

She told Mrs Wilson that she had come to the conclusion that poor Troy's ordeal had been caused by Chita, Mrs Wilson's previous dog.

Chita had also been a German Shepherd bitch and had been with Mrs Wilson since she was a puppy. She was a difficult and determined dog, very ferocious and she hated other dogs. Mrs. Wilson told me, 'she was incredibly hard to train'.

It took endless patience and love, but eventually she became gentle and trustworthy. Mrs Wilson was able to take her to schools and old people's homes, where she was stroked and fussed over and even amidst crowds of children and groups of adults she remained docile. In fact she was a perfect example of the results of loving kindness and training. In return she loved Mrs Wilson with all her heart, was intensely protective of

her and very, very jealous. She had lived a very happy life with Mrs Wilson and died at the ripe old age of fourteen.

Elizabeth stated that she thought it was Chita who had come back to drive the new dog out of the home that Chita believed was hers. She gently, in her own way, informed Chita that the new dog had made no difference to Mrs Wilson's feelings for Chita and that she still loved her dearly. Then she persuaded the unhappy dog to be at peace.

Since that day, nothing has happened to frighten Troy, who has gone back to sleep quite happily in her own place.

9
THE MATRON'S STORIES

The following stories told by my dear friend and ex-matron, Mrs Marian Owen, are quite unblemished by flowery descriptions and phrases, and, indeed, are all the more riveting by being written in the terse, almost stark manner of a professional lady, for the eyes of doctors and fellow staff who only need the essential facts on a report. These people wanted something short – indeed the stories were written in a kind of shorthand, 'complaining of' was condensed into 'c/o'. Marian Owen is a lady of wide experience and common sense, yet belongs to the fortunate people of Wales, who accept that psychic awareness is completely natural. When Mrs Marian Owen retired as a matron after a long nursing career, she and her husband Ivor (a former merchant navy officer) bought a large comfortable farmhouse in Llaneilian, Anglesey, and converted it into a home for two or three of the former residents from her previous position, as matron in charge of a home for the elderly. Mrs Owen, a very intelligent and professional lady, kindly wrote down the following stories for me.

About two years ago, Eirlys (an old lady who lived with Marian) was taken by ambulance to Ysbyty Gwynedd (Bangor Hospital) after falling at Amlwch. She spent most of the day having tests, but by teatime the staff decided that, apart from being slightly shocked, Eirlys hadn't suffered any injury, and if I would pick her up she was free to go home.

It is about eighteen miles to get onto the mainland, and I set off from home about 6.30 pm. Being winter, it was dark but a clear, calm night, and I remember looking up at the starlit sky, thankful that it wasn't raining. The road was empty, except for one car travelling ahead of me, I could just see its tail-lights disappearing on the bends.

I passed through the village of Pentraeth on the Bangor road, and further on I came to the brightly lit Pentraeth Garage and showrooms, a large building on the left hand side going towards Bangor. Beyond that I ran into a patch of mist, the way you do, suddenly in places, shrouding the road on winter's nights. It was then that I saw ahead of me two riders on horseback, going in the same direction as I was.

I slowed down, not passing them because of the double white line, and as I trailed along behind them, I remember thinking – this is dangerous, they are not wearing fluorescent jackets or even arm-bands, someone could come up behind them and smash into the horses.

I drove slowly behind them for some distance, during which time I took in a lot of details without particular interest, other than feeling a slight sense of irritation at their disregard for the safety of their horses and other road users.

They showed up clearly in my headlights – they appeared to be two men, dressed in tweed jackets, and their horses were walking steadily, although their outlines were a bit hazy in the mist.

As I tailed along behind, they drifted gradually towards the thick hedge at the side of the road, and slowly merged into it, they hadn't changed course, they were still going forward, but now seemed to be right *inside the centre of the hedge*. What I mean is, the riders didn't turn the horses' heads to go left, they simply went on, disappearing slowly sideways into and along the hedge. As if the thorn trees were no more substantial than smoke.

I accelerated then, and the whole thing seemed so natural I just drove on normally, and I was past the roundabout at Four Crosses before I realised what I had seen, and I suddenly found myself going cold.

One thing I forgot: the mist disappeared as I accelerated away from the spot, and the night was clear and starlit again.

We visited the spot Mrs Owen described, and I found that the thick hedge at the side of the road was completely compact and impossible to get through. The section of road here is new and straight, cutting off many corners of the old road which it has replaced.

At the spot where the riders veered gradually into the hedge, there is a short loop of the old road, which they seemed to be following, which the new road has cut off

This loop runs for about twenty yards, before rejoining the current road It leads nowhere and cannot even be used as a lay-by, being blocked by the dense thorn hedge.

Are the ghostly horsemen still using the old road – or did Mrs Owen drive unwittingly through a time-warp?

After hearing Mr John Roberts's hospital stories, Mrs Owen told me that she too had had a similar experience when she was a student nurse in an old open-type ward. The patient at the end of the ward was very poorly, and she sat by his bed while the other nurse went for a meal.

'I did a ward round,' she said, 'everyone was asleep except the patient in the bed facing the door. He was wide awake, and when I bent down to ask him if he was alright, he said 'The old man has gone – he's died.'

'No,' I said, 'I've just got up from sitting with him – he's not dead.'

'Oh yes, he's gone,' he answered, 'I've just seen his spirit going through the window.'

I went back to the end bed, and sure enough he had died.

The doctors and nursing staff in hospitals are mostly well acquainted with uncanny happenings, which Mrs Owen's stories confirm. Here is another.

When my boys were young, and Ivor my husband at sea, I went back to nursing a couple of nights a week, while my father looked after the boys.

About the end of that September, a young boy was brought into casualty with severe head injuries, he wasn't expected to live.

He was on a late holiday with his parents at Betws y Coed and had tripped off the pavement and had fallen in front of a car. He was a choirboy at Lincoln Cathedral, a soloist, but was in a deep coma, and was on a life support machine for three months.

The night before Christmas Eve, I was in theatre at an emergency operation about 2 am. The big hospital was absolutely silent, we spoke only when necessary and then in whispers. Suddenly we heard a sound, a lovely sound which came swelling up through the hospital. We all looked at each other, and someone threw open the theatre doors, against all regulations.

Then we heard it properly, and stood rigid with shock.

It was the voice of a boy soprano – singing like an angel, and the song was 'Silent Night'.

Our little boy from casualty ward, coming out of coma after three months. He had no indication that he had been unconscious for three months, and that it was nearly Christmas.

There wasn't a dry eye in the place when we went to tea at 4 am that morning, even the surgeons were blowing their noses!

The Senior surgeon sent for the Chaplain, and we had a little Service of Thanksgiving in the hospital Chapel.

Mrs Owen also tells this story:

I was matron for years at a fine old mansion (which I will not name) which was a home for the elderly, and consisted of three floors, plus cellars and attics.

A number of the elderly relatives used to ask me where the baby was that they often heard crying desolately in the night.

I had no idea and thought they had imagined it, so I told them that there wasn't a baby anywhere on the premises. When they insisted that they had heard it, and the cries were coming from the attics, I explained that they had been listening to the noises the wind makes when it whistles through the old roof.

Then we started employing night staff, and they too complained of hearing a child crying bitterly in the night. It sounded very eerie, coming from the attic area, and some of the staff were upset listening to it. I was puzzled now about the cries, as the night staff were adamant in their statements and they were all very level-headed ladies, until one day we were given an explanation.

An old man who joined us as a resident told us he had been a coachman there in his younger days when the family had been in residence. He remembered vividly and in detail the time a young maid had secretly given birth to an illegitimate child, and in her fear and terror had thrown the wailing new born child out of her attic window in the middle of the night, onto the drive below, three storeys down. Rumour had it that the father was the master of the house – the maid was paid to emigrate and no more was heard of the incident.

At the time we had two old ladies with us suffering from Alzheimer's Disease. Their names were Winnie and Olwen, and they were very fond of each other. Although confused in many ways, they always knew each other, staying side by side from morning till night, and they called each other 'sister'.

Winnie became very ill, really just wearing out from old age, and so we gave her twenty-four hour nursing for a few days. We tried to explain to Olwen, but she was very confused and didn't understand. She missed Winnie's company, and fretted for her, and on the third day of Winnie's illness, Olwen put herself to bed and developed pneumonia.

The day came when Winnie became so ill, we knew she wouldn't last the night, so the deputy matron, who was on call, decided to sit beside her all night, so the two night staff were free to attend to the rest of the residents.

Before going to bed, I called to see how the two old ladies were, and when we went in to see Olwen, we realised that she was failing very fast, so I decided to stay with her. Winnie died early on in the night, so we did the final duties for her.

Before going back to sit with Olwen, we made ourselves a quick cup of tea, and as we sat quietly together we became aware of a soft, melodious whistling noise, which gradually swelled sweetly, eventually filling the room with a lovely musical sound. We listened intently, trying to locate where it was coming from, and realised it was Winnie's room.

I looked at Mrs Davies, and she said

'That's Winnie calling Olwen.'

We walked into Olwen's room. She was smiling and gazing at someone we could not see, then she held her hand out and she quietly slipped away.

When my husband Ivor returned from the merchant navy, I was still in charge at the old mansion, but the council had already decided that it was now out-dated and unsuitable. So a purpose-built house was planned, when a suitable site was found, which meant demolishing the old cottages which were there, and housing the residents in new, and very comfortable council houses.

Ivor and I were chosen as warden and matron, and a modern, self-contained flat on the first floor became our home. Our flat was finished first, and Ivor and I, and our two sons, David and Kevin, moved in.

The place had to be decorated, furnished, and fully equipped with bedding, furniture, kitchen appliances and every item that would be needed to run a home for the elderly. No mean task. A girl was employed to help Ivor sort out the furniture etc.

I was still working at the old mansion, as the residents were still there. That meant that when I was on call I had to sleep there.

One night, I was working at the old mansion and the rest of my family were asleep in the new flat, Ivor had not drawn the curtains and the street lights were shining in.

Of course, we had a dog, he was on the bottom of the bed and he woke Ivor up, growling threateningly, deep in his throat.

Ivor sat up to see what was wrong with him and saw he had his head raised, his hackles were up and he was staring fixedly at the window. Ivor looked too and saw an old lady gazing in at him from the outside. She was wearing a black coat and a red hat, and looked completely real.

He was dumbfounded because the bedroom was up on the first floor and there was no balcony. He said she must have been suspended in mid-air. Suddenly, she vanished, but the dog growled for a long time.

Next day, the front doorbell rang loud and long, as if someone had their finger pressed hard against it. The daily girl, who was in the hall, looked along and saw a woman through the glass panel of the main door.

She called upstairs to Ivor:

'I'll go – it's an old lady.'

She walked along the corridor, and when she got to the door, there was no one in sight.

The two of them searched the grounds – no sign.

Ivor asked the girl what the old lady looked like, and she told him that she had had a good view and the woman was dressed very old fashioned in a black coat and a red hat.

When I told some of the neighbours that morning, they recognised the description at once, they told me her name. She used to live in one of the old cottages which had been demolished to make way for the new home, and she had been killed by a car at the junction of the main road close by.

We moved into the modern nursing home, and one night David forgot his key. We had our own door to go upstairs to the flat. So he walked around to the front door and peeped through the glass pane. He saw the back of me going through the main hall of the home, so he rang the bell.

To his surprise, I went on walking down the corridor and one of the night staff opened the door for him, and he asked, 'Is mam downstairs?' and they said 'No'.

When he got upstairs to the flat, I was fully dressed in the kitchen preparing supper. He was very surprised and he said, 'Gosh! You've had a quick change!'

I didn't know what he meant, until he explained that he had seen me walk down the hall in my pink dressing gown, and, after I had thought about it, I reckon that what he'd seen was the ghost of one of our residents who had died the month before, and she had always worn a pink dressing gown that was a bit darker than mine.

The night staff weren't a bit surprised when I told them. They said they had seen her many a time, she was an ex-nurse with fair hair like mine, and from the back she looked just like me, including the 'nurses walk'. I used to tease them, 'Oh well, she keeps you on your toes!'

Mrs Owen writes about her son David again.

When David was a teenager, and before any serious relationships with girls, he was a CB radio enthusiast.

For better results, he and his mates used to drive to the top of a high old quarry for better reception, and stayed until quite late at night. They could pick up transmissions from England, Ireland, Brittany, France etc., and they used to stay there until quite late at night.

One night, he came in about 12.30 am, very pale and upset, and said:

'Quick Dad, I'm sure I've gone over a body by the cemetery – will you come back with me? I saw her lying in the road. It was a woman with fair hair and a very white face, dressed in black. I was too close to stop and I felt the bump when I went over her, but there was something weird about her. Come back and look Dad, it was by the cemetery.'

Anyway, both Ivor and David went back, they searched both sides of the road but there was no sign of anything, yet David swore he had run over a body.

We listened to the news bulletins all day, nothing was mentioned.

David was certain then, and still is, that it was a ghost he saw.

When Marian was a child, the family had a smallholding near Bethesda and her father was a sheep farmer.

His dog, Blac, worked all his long life for Marian's dad, they made a great team, he was a very intelligent dog who anticipated his Master's commands before he had voiced them.

Blac was much admired by the sheep farming fraternity for his ability to work the sheep, winkling them out of nearly inaccessible crevices, and off the tiny mountain ledges that abound in Snowdonia.

He was quite famous locally, and farmers offered sums between £100 and £200 for him, a fortune in those days. A very lovable, affectionate dog, he was more like a pet to the ladies of the family, who made a great fuss of him.

One fault he had – and one only. If he was working the sheep near home, and he caught sight or heard the voices of the two girls and their mother, he would streak down to meet them. He only had to glimpse the school bus coming along in the afternoon, and would abandon his job immediately, leaving the bemused flock and swearing farmer stranded.

One day, Mr Owen was offered a price for him he couldn't refuse. Blac was sold to a farmer in the Conwy Valley and Mr Owen came home alone. The family was devastated and Marian writes:

We ladies of the family wouldn't speak to dad, we just ignored him, and he looked very guilty. We really made him regret he had sold Blac. How long this situation would have lasted I don't know, but on a cold rainy morning, three days later, mam opened the door and there, lying on the doorstep was Blac. Wet, cold, hungry and bedraggled, after walking many miles out of the Conwy Valley, over the mountains and home.

Everyone (including dad I think) was overjoyed to see him and, of course, he was never sold again! He was so much a part of the family he used to come to chapel with us every Sunday night.

But then Marian's mam died suddenly, and left the family bereft. The first Sunday after her funeral, a memorial service was held in the chapel. Marian's family, as chief mourners, were seated in the well of the building nearest the minister, not in their customary places in the gallery.

During a quiet prayer in the service there was a sudden noise in the gallery, and everyone turned to see Blac in the family pew, gazing down at them with sad eyes.

One day Mr Owen had Blac mated, and chose a pup from the litter who looked most like his father and was the smartest of the lot.

His name became Smart, and Blac seemed very fond of him. Between them, Blac and Mr Owen trained him, and in time he became just as clever as his father. Smart took over the sheep when his father became too old to work, then Blac had a pampered retirement with the family until he died at a ripe old age.

His master too was ageing, so he sold his sheep and started to take things easy, instead of tramping the mountains in all weathers. Smart, out of work now, with no sheep to order about and getting elderly himself, filled in his time by living between two homes, his master's and Marian's, about a quarter of a mile away. He would stay for a week with her and then go home.

Mr Owen started to fail badly during the last months of his life so he and his dog moved in with Marian, and Ivor, her husband. Gradually, he grew weaker, and one Saturday night, Marian knew her father was dying.

Ivor went for her sister, and they gathered around his bed. Old Smart would not come into the house, but lay outside under his master's bedroom window all night.

'He was crying, not loud howling,' writes Marian, 'but a low moaning sound. Dad died at 6am, and the dog had gone quiet so my sister went to check on him – he wasn't there. My husband, Ivor and son David, went to look for him – he had gone home to dad's house, even though he hadn't lived there for months.'

I was so impressed by this story of the sixth sense which dogs possess, I asked Marian what had finally happened to old Smart. 'Oh,' she said, 'Dad had some neighbours who he spent quite a lot of time with after mam died, and they were very fond of old Smart. They asked if they could have him, and we let him go to them. Knowing Smart, if he wasn't happy he would have walked out and come back to us, but they spoiled him as much as we did, and his last years were very happy.

When he was dying, the farmer's wife looked after him like a baby, staying up with him and spoon-feeding him.

One night, he just fell asleep and died of old age.'

10

RUSSIAN GHOST

This story was told to me by my good friend, Mrs Owen, a retired Matron who lived at Maen Dryw, the next farmhouse to ours. She has since returned to Bethesda to live.

It is an interesting story, which, married up subsequently with a different account, has proved to be true in a most positive manner.

I shall relate it in Mrs Owen's own words, from the narrative she wrote for me.

When I was very young, my family were tenants on a smallholding in Mynydd Llandegai, a small village outside Bethesda, near Bangor.

At the end of the First World War, a camp was set up to house Russian and Polish workers, (I think they were refugees) who were employed by the Penrhyn Estate. Some of the men went around the smallholdings (the holders were tenants of the Penrhyn Estate) to maintain the buildings, drain the ditches, cut hedges and even build new barns. The majority, however, were skilled forestry workers who felled the trees at the tops of the hills, which were then dragged down to the sawmill in the valley.

My grandfather said they were always courteous and polite, and some of them eventually married Welsh girls but mostly they kept apart from the locals.

I didn't know about them when I was little, because by then the camp had disappeared; I tell you this so you will understand that I had not a clue about the identify of the ghost I saw.

Well, one summer evening, when I was under ten years old, my sister and I were supposed to be in bed but we were playing around as it was still daylight outside.

I was sitting on the bedroom floor, looking out of the low window, when I saw a man walking through the yard to the front door. Next, I heard him knocking at the door then, after a moment, he stood back and looked up at the bedroom window.

I jumped into bed and called mam and dad that there was a man at the door. When dad went to the door there was no one there.

When they came up later to tell us our bedtime story (their usual routine), dad asked me what the man looked like.

I described him. He had black hair, a thick black moustache, and he had a red kerchief tied around his neck. I told dad he looked funny because he had a white towel on his head with red on it.

When I finished dad and mam looked at each other, and a very funny look passed between them, but they didn't say anything, they just tucked us up and said goodnight.

Years later, I found out that previous to me seeing the ghost (as it turned out to be) my brother Leslie had been in the yard, looking into the shed where my dad was. Just as he looked in, he saw the same thick-set man, with 'something white on his head', standing behind dad, and holding an axe in his hand.

Leslie screamed, and as dad turned round, the man vanished. My brother was very shocked and upset, but when dad had calmed him down, he asked Leslie not to tell his two younger sisters, as he didn't want us to be frightened.

Later on, when Rev. J. Aelwyn Roberts was talking about the ghost which was haunting the little council estate, and described what he looked like, I went cold because it was the exact description of the man I had seen when I was little.

Rev. Roberts had a friend, also Mr Roberts, who was a medium, and when he investigated the ghost, the ghost spoke very earnestly in a language nobody could understand.

By a strange coincidence, two Russian seamen had jumped ship in Penrhyn, had settled down, married Welsh girls and subsequently had families.

The elderly widow of one of them interpreted the ghost's conversation, which in English was 'I'm sorry, God forgive me'.

The second Russian seaman has grandchildren who are still alive – my friend Val is one of them. She told me that her grandmother was taught by her husband to speak Russian, also her grandmother informed the Rev. Roberts of a trial and murder at the camp.

Apparently the police investigated, but the Russians 'closed ranks' and with the added language difficulty, nothing was proved. Rev. Roberts had investigated and it was all true.

This story was given to me by Mrs Owen over ten years ago. In 1998, I bought a fascinating book written by the Rev. Aelwyn Roberts called *Holy Ghostbuster* published by Element Books Ltd.

In Chapter 8, 'Council House Ghost', he gives a gripping account of the ghost. Apparently he had betrayed his countrymen in some appalling way and they had found him guilty, had put him to death and hidden his body in the saw-mill, most probably in the deep, sawdust-filled pit, which lies somewhere under the foundations of the small council estate.

It was in one of these houses, in which lived a normal family, that the earth-bound ghost had been assured by the Rev. Roberts (helped by his mediumist friend Elwyn) of God's love and forgiveness for a repentant sinner.

Elwyn, who could clearly see the Russian, said that 'a smile has come to his sad face, and he is walking away. He is leaving us.'

Another piece of the jigsaw fitted in, when a local solicitor told Rev. Roberts that years ago the firm had on their books a Russian gentleman who wrote to his solicitors twice a year from a mental hospital in Devon.

His letters were incoherent rubbish but the final paragraph was always asking for prayers for the soul of his father who was killed by his countrymen in a village near Caernafon. He always pleaded that his soul should be saved from hell-fire.

The final solution will probably never be revealed. What was his crime, considered so appalling that his life was taken so violently? Perhaps we will never know.

Holy Ghostbuster and its successor *Yesterday's People* are the sort of books I found impossible to put down.

II

SIXTH SENSE?

Mr Maldwyn Jones (who sadly died recently) was born and raised at a farm near the bottom of Alt (or Gallt) Jini, in the hamlet of Bryn Refail, near Moelfre.

In this very haunted area has been seen the apparition of a First World War soldier, a rolling, fiery barrel, a furiously burning house (see *Haunted Anglesey*) and probably many more sightings which have never been recorded. At the beginning of the twentieth century, the agriculture of the Island was at such a low ebb, farmers had great difficulty in making ends meet, and many farms fell into ruin. Many farming families emigrated to America, in the hope of finding a new life. Those who were willing to work hard prospered, and the Anglesey farmers weren't work shy.

They kept in close touch with each other, particularly a group from the Bod Afon area. Three of Maldwyn's uncles, and a married couple from there, all managed to live close to each other in America.

Time passed, two uncles died and the married couple retired, declaring their intention of going back home for a holiday. They were only too pleased to say yes when Maldwyn's surviving uncle asked them to visit his brother who still lived at the family farm on Alt Jini.

As Maldwyn said – he was a young man on his discharge leave from the navy, glad to be back home, and he was just crossing the farmyard on a warm summer evening, when one of the local young men pulled in in his car, and announced he had brought visitors.

Out stepped the couple, and the lady, with a definite American accent, asked Maldwyn if his mam and dad were home. He invited them in, and when his mam looked up in surprise, she immediately recognised her old friends from over the mountain, even though she hadn't seen them for forty years. It took his father a little longer, but when he did, they were both made very welcome.

The talk and exchange of news went on for hours, and the young man who had brought them went home but only after they had assured him that they were quite happy to walk back to where they were staying, over the other side of Mynydd Bod Afon. So he went home, Maldwyn went to bed, and the talk and laughter went on until half-past two in the morning.

Maldwyn's mam and dad were loath to see them go, and said they would walk with them to the top of the mountain, as it was a warm, moonlit night. So, calling the dog,

they set off. Now, this dog (said Mr Jones), was a Collie/Setter cross, very intelligent and sensitive and completely fearless.

They walked up the road, past the church, and came to the top of Alt Jini. Here on the left, stands a lodge at the entrance of the downhill drive which leads to a small pretty mansion named Plas Bod Afon.

In the past there have been many rumours about the area of the lodge, in fact, a few years ago, a group of people were going to visit Plas Bod Afon, but as they turned into the drive, a young woman who was with them suddenly stopped, grabbed hold of the young man next to her and almost collapsed.

He had to support her, as her legs seem to have given way and she seemed about to faint. Her face had gone very pale, and she said 'No – no, please don't go down that drive – something terrible has happened here.'

She was adamant about not going on and could give no explanation or reason for her terror – just kept shaking her head and trembling with fear. Needless to say, the visit was abandoned. This, of course, happened many years after the story which follows.

Maldwyn's mam and dad and their two old friends strolled happily along until they reached the lodge. There, the two ladies remarked that a breeze that had suddenly sprung up was very cold and they linked arms for warmth as they came up to the lodge.

As they reached it the dog, which had been running about sniffing happily, froze in its tracks, neck hair bristling and stared at something in the drive that the others could not see.

Then he hunched his body up with his tail between his legs, and scuttled back to his owner, pressing himself so hard between Mr Jones's legs that he almost fell over. When he was dragged free, he tried to run back the way they had come. After a struggle, he leapt into Mr Jones's arms, hid his head under the jacket and there he crouched, trembling with fear.

They all stopped and looked around, but there was nothing to see that could have scared the dog so badly, but they all felt very uneasy somehow, and the cold wind blowing out of the drive made them walk on, feeling puzzled, and still with the dog in his master's arms.

'It was as if there was something at the top of the drive which had terrified him,' Mr Jones told me gravely 'but no one could see a thing.'

A few yards further on, the dog struggled to be put down, and when he was freed, calmly resumed the age-old dog's method of reading the news in the hedges, and adding his own signature, trotting along as if nothing had happened.

The friends parted at the top of the mountain, the visitors going on their way and the Jones's returning home. As they drew level again with the drive to Plas Bod Mon, and the lodge at the top, exactly the same thing happened, the dog crawling and cowering around his master's legs, begging to be picked up, and once more burrowing under the jacket.

The air was still remarkably cold at the top of the drive, and the dog's very obvious terror made Mrs Jones uneasy, and, although there was nothing tangible to be seen, a sense of fear made her keep close to her husband. She kept looking around nervously, and was very relieved when they had passed the lodge and the dog struggled free.

They both talked about it when they got home, but could not come up with a valid reason.

A few days later, Mr Jones was taking a walk with another friend of his, a Mr Hughes who was born and raised on a neighbouring farm but had now moved to Liverpool to work on the docks. He often came back home and now they were going to see the section of the new road near the Pilot Boat Inn. This road had been built to carry the heavy building equipment for Wylfa Nuclear Power Station and had cut off many of the winding bends of the old road, which had been alright for the carts and carriages of the past but the heavy lorries and their loads found very difficult to negotiate.

The Old Pilot Boat Inn, which had stood on a tight bend for hundreds of years, forced the engineers to slice through straight behind it, so now it was virtually standing on a lay-by.

As they strolled along in the sunshine, Mr Jones was telling him all about the incident with the dog, which still puzzled him, when they met a handsome, strongly built young man coming towards them, on a very fine hunter. Mr Jones knew him very well and introduced him to Mr Hughes as Joe Bradley. Hughes admired the horse and asked Joe if he could take some photographs of horse and rider. He took quite a few from various angles, and suddenly Mr Jones had an idea.

'Joe, can you use a camera?'

Joe nodded.

'Well, in that case, let's hoist Wil up into the saddle, then you can take a few snaps of him, and he can show off to his Liverpool friends.'

Joe grinned, swung down and took the camera, then they hoisted Wil Hughes into the saddle.

As Maldwyn said, 'He was a city man you see, and rather fancied himself on that hunter, so he sat there posing, really enjoying himself, as Joe went around him, clicking the shutter. As he said his thanks to Joe, he said that he was really "made up".'

Joe handed the camera back to Mr Jones with a big wink, and Wil Hughes promised to send him some pictures.

Mounted again, Joe had told them he was on his way to Plas Bod Afon to see his friend Mrs Martin, and he rode on cheerfully with a casual wave.

Maldwyn's father explained that Joe was a superb horseman, the best in the district. He'd had the hunter for nearly a year, and he'd told Mr Jones that it was a very intelligent, patient animal, and the only time it had been nervous was once when they were on Plas Bod Afon drive, when something seemed to have startled it badly, and it had stopped dead, trembling and refused to go on. Joe had to dismount, and talk to it gently, and when he had stroked and soothed it, he lead it on gently by the bridle, walking it slowly, until it calmed down a few yards on.

Two weeks later, the snaps had been printed and Wil Hughes put them in his pocket to show his mate Ivor, who originated on the Island, worked at Cammell Laird's and always travelled to work on the same train as Wil Hughes.

Wil produced the photographs with a flourish, and handed the pictures of himself on horseback to Ivor.

'Well, what do you think of these then?' he asked proudly.

Ivor studied them. 'Grand horse,' he said.

Wil proffered more snaps.

'And this is the man who owns the horse,' he said, 'he's called Bradley'.

Ivor looked at them.

'Oh, I know Joe,' he said, 'or rather, I *knew* him, he's dead – he was killed.'

Wil Hughes was thunderstruck, and immediately asked for details, but all Ivor had heard was that Joe had been thrown from his horse and killed.

That night, on the phone, Maldwyn's father told him as much as was known. Apparently, after Joe had ridden off the morning they had taken the photographs, he had turned into Bod Afon drive and the horse had bolted.

Maldwyn's father said, 'I can't understand it. No horse had ever mastered Joe before, and he and that hunter were very close – almost on the same wavelength, it loved him. Whatever happened I don't know, but he was found at the bottom of the drive, lying there with a fractured skull, no sign of the horse, and as far as I can tell, you and I were the last people to talk to him – it happened just after he had left us.'

Mr Maldwyn Jones has always wondered what made the horse so unmanageable, it must have been maddened with fear, and whether it had been frightened by the same thing that had happened before, when Joe had to dismount and lead it, as he had told Mr Jones, also, how far Joe had struggled with it before he was thrown.

Like nearly all these stories, I needed to dig deeper for corroboration, and the invaluable Mrs Mia Williams promptly gave me the telephone number of her friend, Mrs Gwen Tripp, who was one of the first people at the scene of the accident.

Mrs Tripp kindly recalled as many of the happenings as she could, and this is what she said.

'At the time, my father was farming at Bod Afon farm, which stands at the bottom of Plas Bod Afon drive, just around the corner. I was young at the time, and was in the house on my own, as my family had gone to see relatives. I heard a noise outside, someone calling to somebody else, so I went out to see what was happening. The first thing I saw was Joe, lying on the drive, in his riding clothes, but there was no sign of his horse. My memories of what was going on are a bit faint, I couldn't take my eyes off Joe, but someone else must have been there, Mrs Martin perhaps, I don't really remember who was there, but someone had phoned for an ambulance.

I knelt beside Joe on the drive, I felt so helpless not being able to do anything. I had always wanted to be a nurse, and this made me make up my mind.

I stayed with him until the ambulance arrived. He was deeply unconscious, he never moved or spoke, whether he was dead then, or died in hospital, I don't remember. His skull was badly fractured, as if he'd been thrown and smashed his head on the stone gate post, that's what people believed, but as he never regained consciousness he couldn't tell anyone what had happened. No one saw him fall, or his horse bolting, so we never found out.'

What was it that frightened the dog and the horse so much? The puzzle we are left with is this: both horses and dogs are known as very psychic animals, so what terrified them? Obviously, something only they could sense or see.

On the subject of animals and their sensitivity to things about which we know nothing, as our sense seem to have blunted and lessened over the centuries, I was speaking to a very interesting couple, a Mr and Mrs Joe Darby.

They live in Penysarn, Anglesey, at the side of a track (now a road) which leads up to Mynnyd Parys and was used for generations by many the miners who used to work there.

I've been told by quite few residents that they have heard the tramping of feet on dark winter mornings, and are convinced that when they hear it, the sound is the re-enactment of the old time miners going past on the lane.

Joe Darby has spent his life making horse-drawn vehicles, and a few years ago he was taking his wife for an afternoon drive in what he calls an 'exercise cart', a light, two seater vehicle drawn by his beloved Rosie. Rosie (sadly now dead) was a big strong cob, with plenty of feather, and a very gentle nature.

They decided on a ride that would take them around Parys Mountain, so they drove to Cerrig Man and turned left. It was a lovely day, and Rosie moved at a spanking pace. All went well until they had passed Lord Stanley's house on the other side of the mountain, and started back to Penysarn. Suddenly, Rosie stopped dead. She made a sound that Mr Darby had never heard in his life before, from her or any other horse, and never wants to hear again. It was a high whickering scream of pure terror. Mr Darby tried to urge her to go on, with words of command and a slap of the reins. No use, she just would not move, so he climbed down and went to her head.

In his words, 'She was trembling all over, her head was thrown back, her ears were twitching and her eyes were bulging and rolling. She was terrified, but I don't know why. There was nothing and nobody about, and I couldn't make out why she was so frightened. It took me ages to calm her down, I was stroking her and soothing her but it was a long time before her breathing became normal. Eventually, with me leading her by the head, she set off very slowly again, and gradually she became her old self, but I knew she was glad to get away from that place.

It puzzled me very much, and one day when I met the farmer who owned the land I told him about it. He asked me just where we were when Rosie took fright, and when I told him the exact place he nodded and said, 'Oh, I know where that is. You know, in the old days they used a lot of horses at the mine – they were very well looked after by the farmer who stabled them at his place, Maddyn Drolia, near the roundabout on the Amlwch road, you know, where the fair comes in summer. I believe they planted fields of gorse and cut it in spring before it grew tough and prickly and used it for fodder. The cost of employing blacksmiths and the stabling and feeding of all the horses was tremendous.

But, of course, some of them died at the mine, and instead of bringing the carcases all the way down, some were buried in the nearest soft ground to the mine, and that was the field where your horse took fright.'

Mr Darby said he never took Rosie that way again, she was so distressed, and he's been wondering ever since whether she saw or sensed something in what he called the 'horse's graveyard'.

12

THE HAUNTING OF MONA LODGE

Mona Lodge is a fine looking eighteenth-century mansion that stands at the top of Mona Street, in the town of Amlwch, Anglesey.

It was built by the Marquess of Anglesey for the mine agent of the Mona Copper Mines, a huge working mine that had been worked by the Romans and is still the biggest copper mine in the UK.

In 1811, a brilliant Cornish miner named James Treweek was engaged as the mine agent. He arrived with his wife, Jane, and their five children. He had been very poor and was said to be threadbare when they arrived. What his emotions were when he saw Mona Lodge have to be imagined.

But he settled in very quickly and soon turned the failing fortunes of the mine around by unceasing hard work in every aspect of the mine's working.

He was a very fair employer and always found the best man for the job, even if it meant importing miners from Cornwall. This was resented by the local Welsh miners, but they grudgingly realised that the company had begun to thrive, making more jobs for the locals and the spin-offs that helped the businesses in the town.

James was a commanding figure, well over six feet tall, broad-shouldered and with an air of proud authority.

He learnt Welsh, had Sunday school lessons for the local children in one of his home's largest rooms and began to build the English Wesleyan Chapel in Amlwch, mainly for the Cornish miners and their families.

The Sunday school lessons were all for the Welsh children, and James himself always attended the Welsh Wesleyan Chapel and was a lay preacher.

As time went on, the family of five children increased to nine.

During all his years in Amlwch, James Treweek showed himself to be a truly religious man, with great compassion for the poor. He spent forty years at the mine and all of that time he worked hard for the townspeople, but he was also accused of nepotism as his four sons were all in high office at the mine.

Of the four sons born to James and Jane, the two boys named Nicholas and Francis grew in maturity to be a ship-builder and an agent for copper ore to be sent to Liverpool. They made a great difference to the future of Amlwch Port. The other two, however, even though they were given important jobs at the mine, were weak and dissolute. John Henry was described as a 'drunken, abusive and unruly man' and

when drunk in 1851 stripped off his coat and wanted to fight Dr. Parry, who had been called into him. The other ne' er do well son was William George Treweek, who used to get drunk in public, particularly at the Dinorben Hotel, from whence he was forcibly ejected for trying to blow out all the candles at an important dinner party.

Everyone in the town knew of the drunken habits of the two, except for James Treweek himself, he was now growing old and in ill-health, and his wife Jane protected him from the public shame of these two. In fact he was the last to find out all the facts.

By 1851, John Henry and William George were the laughing stock of the town. William George was the father of an illegitimate child in Amlwch, who was baptised in his father's name.

William was alternatively morbid or furious when he was drunk, indeed, he even tried to commit suicide in February 1851, and when his mother tried to stop him he punched her so hard in her vital organs that not only did he knock her out, but she suffered internal injuries from which she died later in the same year.

He was so wildly drunk that night that a policeman had to be called, to stay with him all night until he sobered up,

James Treweek was now receiving anonymous letters about his son's vices, and these were also sent to Mr Evans, Lord Anglesey's land agent in Amlwch. In fact, so bad were the allegations about the Treweek's family affairs, that James Treweek was at last informed of his son's sins, and the anonymous letters about his own so-called misappropriation of mine funds. This was a great shock to James, who had spent his life as a religious, good living and hard working man. He looked very old and ill and could get no sleep at night. When the rest of his household were slumbering, old James would get dressed, creep quietly downstairs and go walking in the dark, thinking over the hints and lies in the letters and unable to get over the shame his sons had brought on the family. His beloved Jane tried her best to console him, but she became seriously ill, probably (it is thought) as a result of the blow her son William George had given her, and she died and was buried in Amlwch parish church on 30 August 1851, just a few months after she had been hit.

James continued his midnight wanderings, thinking of the problems at the mine, the allegations against his family, the shame of his two sons and finally the death of his wife. The loneliness of his life proved too much for him and the sad and unhappy man died just a short time after Jane, on 6 December of the same year, 1851, and was buried with his wife at Amlwch, aged seventy-two years. James Treweek died a heart-broken, much troubled man and it's no wonder his ghost haunts his old home.

Apart from a few bits of information, I cannot find what happened to Mona Lodge after the Treweeks left. The first solid fact is that a Mr Kyffin Pritchard bought the empty property in the early 1940s and converted it into four dwellings standing side by side.

His grandson, also Kyffin Pritchard, told me he did this by the simple expedient of drawing four straight chalk lines straight through the downstairs rooms and announced: 'These lines are where the walls will be, making four separate dwellings by building them up to the roof and putting in new entrance doors downstairs.' And so they were.

The original ground staircase was circular and wound around the house to the top floor. When the house was altered, this beautiful staircase was bisected on the ground floor, starting at the bottom of No. 3, twisting around and going through the wall into

Mona Lodge. (Photo courtesy of Walt Austin)

No. 2. This pattern continued upwards and each house had to make good the other half of the stairs.

Information about the haunting came in thick and fast. Mr and Mrs Rick Treweek (the great great great grandson of William George Treweek) who live in Sandbach, Cheshire, popped in to visit me, and Rick's charming wife, Moe, supplied me with invaluable information.

I was asked to give a talk to the Dinorben Luncheon Club and there I met an interesting lady called Nia Jones, and this is what she told me:

'I lived at Mona Lodge years ago and it was very haunted. Strange things often happened in the form of gas stoves turned on first thing in the morning, lights blazing in the night in rooms no one had been in, windows opened that had been closed, and objects moved from their places and put in the middle of the room or in the sink.

Someone said it was typical poltergeist activity, but then something very different happened.

Before I tell you what it was, I must say the atmosphere was very good and welcoming, I never felt at all uneasy there. Sometimes I felt that someone was watching me from the top of the new staircase and many times I felt the air moving as if someone was passing by. Sometimes in the hall there was a pleasant smell of tobacco, as if someone was smoking a pipe.

I never actually *saw* anything, but often when I lay awake at night, I could hear heavy footsteps coming up the stairs. It was a bit like a horror film, you know, where the woman is lying in bed stiff with fear, listening to the slow footsteps coming nearer and nearer.

Actually, they weren't a bit threatening and I lay there listening until they had climbed up and passed. I did think that they didn't sound as if they were on our staircase, but I didn't take much notice.

Then one night, my son Rhys, who was about six at the time, came into my room and shook me awake. 'Mam! Mam!' he said, 'there's a man, he's just gone into my room, come quick!' I was wide awake instantly. A man? Burglar? Intruder? I shot into Rhys's bedroom. No one there.

I thought he'd been dreaming and said so, but he grabbed my hand and dragged me back to my room. I saw he was very shaken and a bit shocked, and I realised it wasn't a dream. I sat him down on the bed and made him tell me all about it, and this is what he said.

Apparently, he had got up to go to the loo, and as he opened the bedroom door, a tall man passed him and walked into his bedroom, and as Rhys watched him, he crossed the room, passing through the bed as if it wasn't there, and disappeared through the opposite wall.

We sat on the side of my bed, and he clung to my hand, I could see he'd had a fright, so I asked him to tell me what the man had looked like.

'Well, he was tall, and dressed old-fashioned,' Rhys said, thinking back. 'He had a big coat on that reached nearly to his feet, and a sort of top hat that was very long and high, I think it was black.'

'What was his face like; was he young or old?' I asked.

'Well, he was pale and he had whiskers. I suppose he was a bit old,' Rhys said.

To someone aged six, I suppose anyone over thirty was old, so trying to guess his age was no good.

'Did he say anything?' I asked.

'No, he didn't seem to see me, he just looked straight ahead and walked through the wall – who was he Mam?'

I said I hadn't a clue, and as Rhys didn't want to go back into his old room, I tucked him up in my bed and he fell asleep in no time.

A few days later, my friend Liz came to stay overnight, and she slept in my bed while I stayed downstairs on the settee. When she got up next morning, she looked weary and bleary-eyed, and she said at once:

'What on earth was all that row in the middle of the night Nia? I couldn't sleep for it.'

'What row?' I asked.

'You washing all those pots and pans at half past three – there was enough for an army – it seemed to take you ages, crashing them about.'

I told her I'd never moved all night – never even woken up – but she insisted the racket had gone on for ages.

My lounge, where I had been sleeping on the settee, was right next door to the kitchen and I hadn't heard a thing, but she was upstairs and couldn't sleep for the din, we couldn't explain it.'

A few days later, Nia was talking to Janet who lived at No. 3 and telling her about Liz and the noise in the kitchen that had kept her awake. Janet listened intently, then she said,

'I had a friend who came for coffee a couple of weeks ago,' (Nia could not remember the friend's name, so we decided to call her Ann). 'She had never been to the house

before and when she had been in the room for a short time, she became very quiet and started to fidget nervously.'

Usually they chatted and laughed, as good friends do, but today conversation between them became spasmodic and forced. Janet sensed there was something amiss when Ann kept looking over her shoulder, or peering into corners.

When Janet came into the room with a tray of coffee and Welsh cakes, she found Ann sitting bolt upright, staring down the hall through the open door. When Janet touched her on the shoulder, she started violently.

'Ann, what is the matter, you're as white as a sheet,' Janet said, putting a cup of coffee in front of her.

Ann looked at her – big eyes in a white face.

'Is this house haunted?' she asked quietly.

'I don't know. Why?'

Ann was silent. Then she blurted out:

'I was looking through the door at the hall, when suddenly a little lady came down the stairs and walked along the hall.

She stopped halfway down at a mirror on a hall stand thing – it had a little table with walking sticks at the side – I know there isn't one there, but I saw it.

She picked up a hat, it was a black bonnet with long ribbons on that she tied in a big bow under her chin, then a pair of long black gloves, she was looking at herself in the mirror, then she walked along to the front door and just disappeared through it.'

There was a short silence, Janet was staring at her fascinated, then she said, 'Were you afraid? You know we haven't even got a mirror in the hall.'

Ann shook her head. 'Not at all.'

'What did she look like, could you see through her, did she look like a ghost?'

Another head shake. 'Not a bit, she looked as solid as you or I – at first I thought it was someone in fancy dress, but only for a moment. She had a crinoline on, dark stuff – it could have been navy blue – and sort of layered, and a short cape that curved at the back.'

'What was her face like – was she pretty?' Janet asked curiously.

'Yes, I suppose she was, she didn't look young, probably in her forties.' Ann thought for a minute then said, 'I only saw the side of her face, her hair was parted in the middle and looped around her ears.' Ann pulled her own long hair back to demonstrate a simple hair style, 'And it was done in a sort of knot, low down at the back of her neck. I got a good look while she put her bonnet and gloves on, walked down the hall, and *through* the front door, and I mean through, she didn't open it, just walked through it.'

Nia listened to this story intently while Janet told it, then she said, 'I wonder if she was his wife?'

'Whose wife?'

'The man who walked through Rhys's bedroom.'

'But who was he – and her, for that matter'

'I don't know, but let's try and find out,' Nia said stoutly.

'Before we do anything – I've got some more things to add to your story,' Janet said, 'let's have some coffee, and I'll tell you.'

When they were sitting comfortably, Janet, who had been looking thoughtful, sipped her coffee and said to Nia.

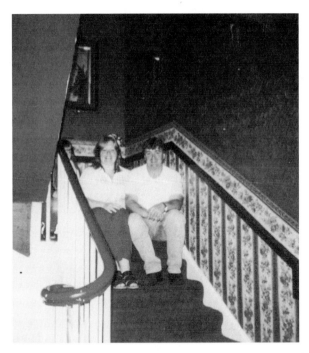

Janet and Wynne Hughes, 3 Mona Lodge. Sitting on their half of the original eighteenth-century staircase, with the original bannister on the left and the false wall on the right, boxing off the other half of the width of the once-grand staircase. (Photo courtesy of M. Treweek)

'Yes, I do believe this house is haunted, and by more than one ghost. I've heard in the town that one of the maids became pregnant by one of the Treweek sons, she hung herself in the stables, and her ghost has been seen in and around the stable yard. That's one. You've seen a lady come down the grand staircase. That's two. Also, my uncle was staying here, and he was in the bath (you know the bathroom is on the ground floor), when a tall man with whiskers and wearing Victorian clothes, walked through the wall, straight across the bathroom and through the other wall, where the original back door had been.

Also, when my husband was working nights at the Power Station, I was sitting reading in the front room, when the door handle began to rattle like mad, but nobody came into the room. I thought it was the children who had got up and were playing tricks, but when I jumped up and opened the door, there was no one there, and I checked and found the children were fast asleep in bed, and there was no one else in the house.

Also, last summer, we were all in the garden on a hot day and I decided to come in and put something cooler on. I was standing in the bedroom in my slip, when I heard heavy footsteps coming upstairs. They were too heavy for Wyns' footsteps and anyway, I could see him sitting in the garden with the children.

I was a bit scared and I stood like a statue listening, slow heavy footsteps they were, but they went past my door, right along the landing and through the wall at the end.'

Asking around the town about the hauntings, I was told that although the noises have been heard at different times, the ghost of James Treweek has only been seen at night,

which seems to give credence to the fact that the poor man could find no rest in his bed in the final months of his life, and took to going out walking to try and find answers to the insoluble problems on his mind, and the great hurt and grief in his heart.

He had no appetite for food and with no sleep, he grew weaker and weaker, but still he strove to fulfil his duties at the mine, until on 7 November he could go on no longer.

After that day he became bedfast and died on 6 December 1851, aged seventy-two, just a few months after his beloved Jane.

Many said that he died of a broken heart and his body was laid to rest beside her on 11 December of the same year.

His body was laid to rest but his ghost is still seen restlessly tramping in and around the big house, which to his ghostly eyes is exactly as it was when he first entered it as a young and happy man.

13

THE GHOST CHAIR
(CADAIR BWGAN)

I am indebted to three very kind people for the details of this story, which is quite famous and well known in Anglesey.

Michael Bayley Hughes, who produces many Welsh documentary TV films, his presenter Gwyn Llewelyn, and John Roberts of Brynteg, have all helped with the story. Here it is:

Between Maenaddwyn and Bryn Teg, runs a back road, hedged thickly on each side, and in the hedge, hidden by brambles and long grass, there stands a large stone, which is in the shape of a chair. For hundreds of years it has been known as Cadair Bwgan, meaning Ghost Chair. It has been the site of many supernatural happenings.

The first one I heard about happened approximately a hundred years ago to a farmer who lived at Brygan farm, which stands close to the chair stone. He was coming along the back lane with a loaded hay-cart, and he had just drawn near to the stone when suddenly a great wind sprang up around him, so forceful that most of his hay was whirled out of the cart, flew into the air, and was deposited all over the hedge and into the nearby field. Although it was so strong, it seemed to be confined to a very small area, as his cap stayed on, and the ambling horse was quite unaffected.

The farmhand who accompanied him to fork the hay up into the loft, and was at the horse's head, had no idea anything was amiss until he heard his master shout and looked over his shoulder to see a towering swirl of hay lifting out of the cart, and being deposited onto the hedge.

There have probably been many unrecorded happenings since then, but Michael sent me an email about something that happened a few years ago to the father of Gwyn Llewelyn (presenter of Michael's TV documentaries).

Apparently, he was cycling along the back road and, as he drew near the stone, a strange whirlwind swept under his bicycle, and he said it was so strong it lifted the bike into the air, he was flung off, and after twirling through the wind, the bike crashed to the ground several yards away. Gwyn's father was unhurt, but picked up his bike and fled.

Also, said Michael, he interviewed a young boy at a nearby farm who had a frightening experience when, alone in the room, a large ball of light came slowly down the chimney, floated towards him and vanished.

I was talking about the Ghost Chair to Mr John Roberts of Bryn Teg and he listened with interest, then he said:

'I know something about the Chair Stone, and it happened to a great friend of mine, William Richard Hughes.

He was in the Royal Flying Corps in the First World War, and he joined it again when it became the Royal Air Force in the Second World War, as a pilot. He was a very brave man and had been in some very tight corners, but never lost his cool.

After the war, when he lived at Capel Coch, he used to cycle to the California Inn occasionally for a pint and a chat with his friends, and he never got drunk or anything.

One night, he was cycling back home from the California, as he had done many times, and he drew level with the Ghost Chair. Suddenly, something shot out from the stone, so quickly he was unable to describe it and it went into his front wheel.

Immediately, the front wheel turned bright red, like a burning coal, and it looked red hot. Showers of sparks flew out of it, all kind of colours, like bright fireworks, lighting up the road all around the bike. He was so shocked, he said his hands seemed glued to the handle bars and he couldn't even move them to squeeze the brakes on.

He was travelling slightly downhill at the time, which was a good job, as he seemed to be completely frozen, and his feet were immovable on the pedals.

The multicoloured sparks were still flying off the wheel, and they continued until he reached Brygan Lodge further down, when they disappeared as suddenly as they had materialised.

Then feeling came back into his body, he was able to move again and he jumped off his bike and stood trembling in the road. Everything was normal but for the life of him he could not get back on the bike again, so he walked all the way back home to Capel Coch, which is a very long way indeed.

He bravely cycled that way many times again, at all hours of the day and night and, as he told Mr Roberts, he was very tense every time he approached the stone but he never saw anything again. Mr Roberts told me that he was the only person William Richard Hughes had told and it remained between them, untold to others.

The Ghost Chair. (Photo courtesy of Michael Bayley-Hughes.)

14

STORIES FROM MR JOHN ROBERTS

These are the sort of ghost stories which should be told seated by a cheerful, crackling fire on a cold winter's evening – which is exactly the scene when Mr John Roberts of Bryn Teg, Anglesey, came to settle down in the warmth of our farmhouse.

When he had sunk into a comfortable armchair and stretched his toes to the fire, he refused a cup of tea and launched into his tales straightaway.

Old William Roberts from Aberffraw used to work on a farm there, he was in charge of the horses, and when he first started working there he was told that as soon as he came to work (which was very early in the mornings) his first job was to go into the stables.

The first morning he went in, he found the horses were sweating and trembling with fear. They seemed glad to see him and gave a little whinny when they saw him, he wondered what on earth had frightened them, so he talked softly to them and stroked them to calm them down.

Then, to his great surprise, he saw that every horse's mane was beautifully plaited. It had been done with great care and expertise, just as if someone proud of them was going to take them to a show. He unplaited their manes, and it took him ages because they were done so beautifully. It was done by someone who cared for them, but William thought that the horses were afraid, because they knew whoever visited them was not 'ordinary'.

It was the same every morning when he went in and he always had to unplait them, he couldn't take them into the fields to work all done up like that, because the next door neighbour would laugh at them, so every day he would have to unplait their manes, and it would take him ages because they were done so beautifully. He was very puzzled, so he asked the master of the house about it – did he know and could he explain it?

His master laughed and said, 'Yes, I know about it – people say the fairies come at night and ride them!' He wasn't at all curious about it, he just shrugged it off as unimportant. But William Roberts wanted to know more, so he asked one of the men.

'Have you ever seen anything wrong at this farm?'

The man looked puzzled, 'How do you mean, 'wrong'?'

'Do things happen that you can't explain?'

He nodded. 'Oh yes, lots of things.'

William was intrigued. 'Like what?'

'Well many times when we are sitting waiting for our dinner, the loaf will float from one end of the table to the other – with nobody touching it – all by itself! And sometimes the door will open and close, and nobody comes in. Lots of things, plates fall off the dresser onto the floor without breaking when they land, or a chair will move out from the table and then back, just as if someone has sat down, all sorts of things.'

'Aren't you all a bit scared? Doesn't anyone do anything about it?'

'Like what?' said the farm hand.

'Like getting a priest in or something to find out what it is?' said Will.

The man shook his head.

'It's not important whatever it is,' he said. 'It's done us no harm, besides, the men would think it soft to be scared.'

So they all accepted it.'

'Isn't that incredible?' Mr Roberts said, 'and yet people still won't believe that there are things happening all around them.'

'I wonder,' I said, if it is something we just don't understand yet – I mean, we wouldn't have understood a couple of hundred years ago about how radio waves travel through the air, or television pictures, perhaps it's something we just haven't got around to understand how or why we see ghosts.'

'Yes, yes,' Mr Roberts said absently, following his own line of thought.

'There is another case I know of – a very unusual one.

There was a young boy who was terminally ill, in a hospital in Manchester, and the family knew there was no hope for him.

His father was a fairly old man, and the boy's mother had died a few years before.

Anyhow, the old man had his farm to look after, and going to Manchester was like going to America in those days, so it was decided that the boy's brother should go, as they knew the little boy had not many days to live.

So he did and, when he got there, a nursing sister took him to the matron.'

Here Mr Roberts looked at me and said sadly:

'We miss the old matron don't we?'

I nodded.

'Anyhow, the matron asked the young man if he would describe how his mother looked when the little boy knew her. So he said, how tall she was, hair colour, clothes, etc; and when he had finished they looked at each other and nodded.

'It is her,' the matron said. Then she turned to the brother and said, 'Do you know, your mother sits at the boy's side all night and all day. If the nurse goes in in the middle of the night she is there. If we go in at any time during the day, she is there, and as soon as we appear, she vanishes.'

The little boy only lasted two more days after that, and his mother was always with him, but they never saw her again after he had died.'

'Talking of matrons,' I said, 'Mrs Marian Owen, of Maen Dryw, was once Matron at the old hospital in Bangor.'

'The C and A,' Mr Roberts nodded. (Caernarvon and Anglesey.)

'That's it, the C and A, and she told me that one of her patients was an old lady who had been severely scalded, she was dying and her son was sitting at the side of her bed. At half-past five he went into the nurses' station, and said to them,

'It's no good me staying any longer, my mother's gone.'
The sister said 'Oh goodness me,' and hurried to the old lady's bed.
She felt the old lady's pulse and said, 'No – no, she hasn't.'
And the son said firmly:
'She has, she just went towards the window while I watched.'
And ten minutes later she died.'
We sat in silence for a moment, then Mr Roberts said thoughtfully,
'There was another lady, Miss Williams, she was my teacher in elementary school, and she would not tell lies, nor would she imagine things. Her father was very ill, and he was in bed at home, there was no such thing as a hospice in those days. His friends and family took it in turns to go to his house and stay by his bedside day and night.

It was my cousin's turn to take over and, as he walked into the bedroom, the man he was relieving drew him aside and whispered quietly:

'Look here, don't be upset or anything, I want to tell you something strange. Every evening at five to eight, the sound of soft harp music starts up at the head of the bed, and it keeps going for exactly five minutes.'

Then he squeezed my cousin's arm, and tiptoed out. My cousin settled down in the chair, to watch over the sick man.

Sure enough, this beautiful harp music started and circled softly around the bed for five minutes, and stopped at eight o'clock. This happened every night, and continued until he had passed on. Now, Miss Williams was telling me she was her father's girl, and that she grieved bitterly for him, cried every morning, she came to school and you could see her eyes were all red.

It was just before Christmas, she was working at home as well, they had a small farm, and she was going to feed the geese. She was just about to go up the stone steps, when she looked up and there at the top stood her father.

It was such a shock, she just stopped and stared at him. Then he spoke to her and said,

'Look here Mary, don't you get upset for me, don't cry – I wouldn't come back for all the world.'

And he gave her a loving, gentle smile and faded away. After that, she stopped fretting, she was very comforted.

There was a silence which Mr Roberts broke by saying:

'I remember my eldest brother, he was killed in the First World War, he had been in the big push at Ypres, and my mother was broken-hearted, no one could comfort her. Anyhow, she was coming home one night, a moonlit night it was, and she saw him waiting for her on the road in front of our house. He was wearing his uniform, and smiling at her, and, although he vanished before she could speak to him, from then on she was at peace, no more crying.'

I then told Mr Roberts about the strange sightings on the Bangor road near Bryn Refail (*Haunted Anglesey*), and we talked about different people from all walks of life who had weird experiences on roads, for which they could not account.

Mr Roberts told me this:

There was an incident on the Llanbedrog road, and this is what happened.

A gentleman who was a friend of mine was motoring along the road one night, a windy, rainy night, and he saw in his headlights, a young girl standing at the side of the road facing him, with her arm out as if to flag him down.

He stopped and opened the door, as he couldn't leave her stranded on such an awful night, he leaned over and asked her if she wanted a lift.

'Yes, thank you very much,' she said, and got in next to him.

'Where do you want to go to?' he asked.

She pointed out a light on a hill, about half a mile further on.

'I want to go there,' she said.

So they set off, it didn't take long, and he tried to make conversation about the awful weather, but she just nodded and he thought she must be shy.

When they drew level with the light, he could see it was a farm on their right, at the end of a long straight drive.

'Is this it?' he asked her, she was looking through the windscreen, staring hard at the house, and she nodded again.

'Right,' he said. 'I'll take you up to the door, you'd get soaked just walking up the drive.'

So he drove up to the house, and turned the car around at the top, so that he was right outside the door.

'There you are young lady,' he said, 'how's that for service?' And he turned around to smile at her, and found himself looking at an empty passenger seat.

The shock was so great, his heart jumped in his chest, and he couldn't breathe. He thought he must be going mad, and he rubbed his eyes with his hands.

At that moment, he saw a downstairs curtain twitch, and someone looked out at him.

'Well,' he thought, 'I can't just drive off and leave these people wondering why I have driven into their yard.'

So he got out of the car – he said his legs felt like jelly – and knocked on the door.

'Come in,' a woman's voice called, 'it isn't locked.'

So he went inside, and a woman with grey-black hair was standing near the fire. She took one look at his shocked face, and said gently:

'I know what's to do, I'm her mother – come in and sit down, I'll make you a cup of tea, I know you're upset.'

He sat down heavily, and when he found his voice, he said to her,

'You're her mother?'

And the woman, who was just brewing tea from the kettle on the fire, nodded.

'Well,' said my friend who was still in shock, 'I brought your daughter here, in my car, right up to the door, and when I turned to speak to her the seat was empty – she wasn't there and she hadn't got out – I don't know where she...'

His voice trailed away, and he shook his head in a daze.

The woman patted his arm and said sadly:

'You see it's her birthday today, and for years, I don't know how many people have brought her here on this night, and, just like you, they have stopped here and the car is empty. She was killed by a car just near the spot where you picked her up, she was coming home in the dark on her birthday.'

'Is it still happening?' I asked Mr Roberts.

'I suppose it is, yes,' he replied.

'There was another instance,' Mr Roberts went on, 'and the gentleman in question still lives in Llantrisant today. He was coming home one night from Rhosneigr, and he got to Bodedern crossroads, and an old lady stopped him and said:

'I want to go to Bodedern church.'

And he said, 'I'm not going that way but I'll gladly take you.'

So he took her, and when he stopped at the church she wasn't there, and that man was in bed for two days with shock.

Also, about two years ago, something similar happened on the A5 between Menai Bridge and Llanfair PG. This man was going home from work and he saw an airman waiting for a lift at the side of the road. So he picked him up and asked where he was going.

'I want to go back to my base, the RAF station at Valley.'

So the driver took him, and the RAF man was very quiet, but once the car pulled up outside the station gates, the driver found he was alone in the car.

I said I had heard of hitch-hikers who turned out to be ghosts. The stories come from many countries and can be traced back to happenings before cars, back to the days of carriages and carts.

We were both thirsty by this time, so I asked Mr Roberts please would he have a cup of tea (a panad) before we went on.

I told him my head was buzzing with so many stories, and how weird things were still happening every day.

He agreed and said with a chuckle,

'You'll be afraid to go out after dark now, cariad!'

I shook my head.

'I'm not going to go out after dark – I'll make sure of that!'

We had our tea, and then I said to Mr Roberts:

'Remember what I told you about my friend Mrs Marion Owen, the retired matron? Well, she told me about a friend of hers at Bethesda who was going to catch his early morning bus to go to work. It was about half-past six on a dark winter's morning, with no one about. As he walked to the bus stop, he saw in a pool of light from a street lamp, a man lying on the ground and another one bending over him.

He thought there had been an accident, someone run over, so he ran to help. Just before he reached them, the whole scene vanished. The road was empty, just the lamplight shining down.

Marian said the whole thing shocked him so much he was in bed for six weeks with a nervous breakdown.'

'I can understand that,' nodded Mr Roberts.

'Are you sure you won't have another cup of tea?' I asked.

He refused politely.

'Then let us get on to part two,' I said, switching on the tape. We settled back and Mr Roberts started again.

'Right, coming closer to home now, a personal experience. I was shooting with Ted Hughes, of Rhos Goch, and we had left the van on the road and walked a long way, all around the farms. Ted Hughes had shot a pheasant, and it was a runner and he couldn't get it.

It was dusk now, but he wouldn't leave it injured, not Ted, and the dog was partly trained, so he said to me, 'could you walk back to the van, we've left it on a side road, there are no lights on, and it's getting dark.'

It was quite a long way away, about half-a-mile, so I went to it, put the lights on and walked back. As I got near the place where I'd left Ted, I could see a man coming towards me through the dusk.

'Did you get it Ted?' I asked.

No reply.

'Where's Sam?' I asked, that was his dog.

He didn't answer.

'Where's your gun?'

No gun. He didn't say a word.

Then he passed me.

'Ted?' I said. I wasn't afraid any more than I am now, I wasn't frightened at all, I thought it was Ted you see.

'Ted?' I said 'What's wrong with you?'

He took no notice. Just walked on. His clothes made a flapping noise, just like oilskin trousers you know, rubbing together. So I followed him and tried to catch up with him, but the more I went, the more he went in front of me. Then he turned aside, walked through a closed gate and vanished. He didn't open the gate, he simply walked through it. I couldn't get over it. I've thought about it often.

There was a feeder-trough inside the gate and the field was full of sheep, and if he had been a man the sheep would have come running, thinking that he had come to feed them – but they never moved.

So I walked back and there was Ted with the pheasant, his gun and Sam.

I'll never understand it, who he was and why he had come back. He was the first ghost I had ever seen.'

———————

'A few weeks ago, on a warm summer morning,' said Mr Roberts, 'I was walking past the Midland Bank in Llangefni, and an old farmer I knew was sitting on a bench outside. I hadn't seen him and as I passed he called me back.

'Hey, John,' he called, and I turned round. 'Are you in a hurry?'

'Not too much of a hurry,' I said, and went to sit beside him. I could see he wanted to tell me something.

'Can you believe this?' he asked me earnestly and went on without waiting for an answer. 'When I was a little boy,' he said slowly, staring down at the pavement and clutching the top of his stick in both hands, 'there was some misunderstanding between my mother and my father. I don't know what happened, but my father was in a great rage. He was a big strong man and I think my mother must have been afraid of him. Something had been broken and when he asked whose fault it was, who had done it, my mother blamed me.

My father was so angry, he gave me an almighty kick. I couldn't walk for weeks and I was in pain for months, it made me lame, and, as you can see, I've been lame all my life.

Well, time went on, they died and I got married and had children of my own, but the pain has never really left me. Well, last week, I went with my son to clean up my mother's grave, the weeds and grass have grown very fast this year. We went in my son's car and he said to me, 'I'll leave you here, Dad, and I'll come back to pick you up in about two hours time.'

'Right,' I said and I started to kneel down with my fork and bucket. I'm a bit stiff at kneeling, you know, with this leg, and when I got down, I turned around for the fork,

and there at the foot of the grave stood my mother, looking just like she did when she was alive.

It was a great shock, and I just knelt there and stared at her.

She looked at me very sadly, then she said gently—

'Owen, can you forgive me for what I've done?'

And Owen said at once:

'Yes, Mam,' and she gave him a wonderful, loving smile and faded away.

'Now you see,' said Mr Roberts seriously, 'he wouldn't just call me out of the blue like that if it hadn't happened, would he? Amazing how love goes on even in the next world.'

WHO GOES THERE?

When we were children, every Saturday we would wait for grandad to pull his chair out from the fireside corner, then we would all sit on a cushion between his legs, and he would tell us a story. This is one I have never forgotten.

Grandfather said:

'Years and years ago my father told me this story, when I was a small boy.' (So that makes it about the 1840s or earlier.)

'He said a friend of his, John, who was not very old, just newly married, was coming home from work (he worked on a farm) one evening. It was a very calm moonlit night, and he saw a large group of people coming slowly along the road towards him.

As the group got nearer, he realised it was a funeral and he was amazed that it was taking place at night. Who would ever want to be buried in the dark?

So he stood well back on the grass and removed his cap out of respect. When the hearse drew near he could plainly see the two men walking beside the horses, and he knew them as men who worked for the local undertakers. There was something very odd about them, then he realised what it was. There was no jingling of harness, no sound of the horses hooves, the wheels of the hearse didn't rumble on the rough road and the men's boots made no sound at all.

Silently the hearse passed, then came the mourners. He recognised his next door neighbour and his wife, also the local farmer, the shopkeeper and many more people, mostly his friends. His attention had been all on the hearse, so he missed the first line of mourners, but as he looked back at them he saw a woman supported by a tall young man and a young woman, all dressed in black. They looked vaguely familiar, but he couldn't see them properly in the dark. The utter silence was eerie. No one moved their heads to nod recognition as they went by – in fact their faces were all set forward and they looked wooden, 'as if they were sleepwalking' as he said later.

The very space around the funeral party seemed unreal, and as the night swallowed them up in silence, he realised that he had become very cold as they all passed, and he knew he had just witnessed something uncanny.

John finally got his stiff body to move, and in a state of great shock and fear, he pressed quickly on home. When he got there, he was very shaken and he told his wife. She laughed at him, and poo-poohed the whole thing, telling him he'd got confused with the moonlight making shadows. But he shook his head.'

'I'm telling you woman, there was no sound, no sound at all, and it all passed without anyone saying a word, as if they were all in a dream, sleep-walking.'

His wife placed his supper on the table – told him to get it while it was hot, and shook her head when he wanted to say something – 'You imagined it all,' she said as she went back into the scullery.

'But there was no sound at all,' he said to her, retreating back.

For the next few days, it was the only thing John could talk about, he'd become quiet and thoughtful, but he discussed it earnestly with his friends, the firmest friend being Nan's great-grandfather. He repeated the details over and over again, which people were there, and the places they took in the funeral cortege. The people he told his story to, believed in his earnestness and puzzlement, and in their turn, told their own families.

Within a week, John, fit and strong as he seemed, was dead of a heart-attack, and his funeral was exactly the same as the phantom one he had seen, even to the identity of the undertakers, and all the followers.

The one thing he had missed (which was probably a blessing) was that his wife (now his widow) had been right behind the hearse and she was supported in her grief by his brother and sister-in-law.

He never suspected that he had been witness to his own funeral, which in reality took place a few days later.

15
THE ON-CALL ROOM

A few weeks ago, I had to go for an eye operation that lasted over an hour.

This was at HM Stanley Hospital, St Asaph and was performed by one of the most eminent (and charming) eye specialists in the country. He has asked me to withhold his name, so I shall therefore refer to him by his initial – Mr N.

During the whole time he worked, we kept up a very animated conversation about ghosts. We chattered happily, the theatre sister joined in, and I never thought once how difficult and dangerous the operation was (one tiny slip and I could have been blind in one eye) such was the ease and proficiency with which Mr N worked.

To my delight, he told me about an inexplicable experience he had as a young doctor, and I will tell it in his own words.

'Years ago,' said Mr N, 'when I first started in medicine, I was a houseman in Warwick Hospital. All junior doctors work for a period in hospital to gain valuable experience.

It meant hard work and long hours, but I was quite happy. There were quite a few junior doctors there and I shared a flat with some of them, a distance away from the hospital.

One night, there was trouble on a ward and I was worried that it might flare up again during the night, when the ward had only female nurses to deal with it. So I decided to stay, and after consulting my senior (who thought it was a good idea) I asked him whether I could have a room and be close at hand. He was on his way home and paused briefly to tell me that there was an 'on-call' room somewhere along the corridor and suggested I should use that.

When I found the room and went in, everything seemed normal. The bed was made up, there were towels etc; it was sparse as all other 'on-call' rooms are, but it had an air of desolation and disuse and a feeling of coldness about it.

The heating system was working perfectly, of course, and the radiator was very hot but still the room seemed cheerless.

But I was young, I had worked many hours and I couldn't really care less as long as there was a bed to crash into. So I informed the girls in the nurses station that I was on hand to wake me if I was needed – and went back to the room.

The atmosphere hit me as I walked in – heavy and even colder, so I went to the radiator to turn it on fully – to my surprise it was. It didn't seem to emit any warmth into the room, even though it was quite a warm day for November.

Anyway, I was so tired I fell asleep as soon as I got into bed, but a few minutes later I woke and sat up with a start, thinking it was someone in the room.

I hadn't heard anyone knock at the door, but for a moment I thought it was one of the nurses who was leaning over me, trying to wake me up.

'OK,' I said, 'I'm awake,' and leaned over to switch on the bedside light, still conscious of the figure above me.

I found the switch and light flooded the room – an empty room. After a minute or two, looking around me, I decided I had dreamt it and settled down again. As I was drifting off, I was suddenly sure that I was not on my own and the room was full of people. I stretched for the light and for the first time I felt absolutely icy-cold. Once more I gazed about me, I could not throw off the feeling that I had been the centre of a crowd of people, all whispering and moving about. Shivering with cold, I slid down in bed.

Well really, that's how I spent the night. Sleeping spasmodically, having nightmares that the crowd was gathering about the bed or else starting awake suddenly, convinced that the muttering and moving had only stopped the moment I woke up.

I never got warm all night, and I got up early because I hated being in that room with its awful atmosphere.

Later, as I was making my way to the canteen for breakfast, I was joined by another houseman and a senior doctor.

'Morning N,' said my friend, 'you look rough – talk about bags under the eyes, you've got portmanteaus! Have you been working all night?'

'More trouble on the ward?' asked the other.

'No, no trouble at all. I stayed here to sleep in, but I might as well have been working for all the rest I got,' I said bitterly. 'I've never had such a rotten night in my life – talk about nightmares – I kept thinking there was someone in the room.'

The older doctor stopped and looked at me sharply.

'Which room were you in?'

'I stayed in the 'on-call' room,' I said, trying to smother another yawn.

'No wonder you didn't sleep,' said the senior medic, 'nobody ever uses that room, haven't for years – it's badly haunted.'

Before I could say anything, he peeled off into a room, leaving me with my mouth open.

I asked discreet questions amongst the staff. It was a well-known fact that the room was haunted, nobody knew why it was, or what by, but everybody gave it a very wide berth.

That included me, I never had to stay overnight again but I would have spent the night in a chair in the day room rather than lie in a comfortable bed in that eerie room, sharing it with the beings who already occupied it.

16

THE CI DU (BLACK DOG)

Amlwch Port lies in the north-eastern corner of Anglesey, and in the nineteenth and early twentieth century it was a very busy port, ships taking copper ore from the mines.

It has been a port for fishermen for centuries, even whaling boats set out from there, and the square of fishermen's cottages, once the heart and history of the village, reached by narrow paths from the port, has now been knocked down; both cottages and lanes have been replaced by modern houses and wider roads.

About fifty years ago, however, this was not the case, and the 'Ci Du' or Black Dog was seen quite often.

In this particular instance, however, I have changed the name of the lady who saw it because although she is dead, her relatives still survive her and it is in deference to them that I do so. We shall call her Ellen.

One October evening, many years ago, Ellen and her friends had been to a Thanksgiving service at church, they had called in for fish and chips on the way home and it was now quite late. They strolled along, eating, chatting and laughing happily. Gradually, one by one, they all turned off to their own homes and, after passing the little school, her last friend said goodnight and Ellen walked on alone.

Her way home lay along a narrow lane, her house was at the top, and she had got to about six yards from her gate when, raising her eyes from the ground, she stopped abruptly. Standing inside the gate, looking at her, stood a huge dog. It looked like a black mastiff and it was so tall at the shoulder that it stood as high as the gate, which was about four feet. For some reason Ellen suddenly couldn't move. She seemed to be stuck to the spot, as she stared at the dog. It stood immovable, staring back at her.

As she said to her friend later, 'I know it was just a dog, I kept trying to think that, but when I stared into its eyes, I knew it was no ordinary dog. Its eyes were golden, so bright and gleaming they seemed to be lit from inside, I've never seen eyes like it before and I never want to again. And it was so still. It never moved its head, wagged its tail or even moved.

It was only its eyes that seemed alright and they burned into me.

It didn't snarl, bark or threaten me in any way, but suddenly I was filled with a great fear, a great sense of foreboding. So I turned and ran.'

Ellen ran back to her friend's house near the little school and banged on the door in a state of collapse.

Her friend helped her in, made her sit down and gave her a panad (cup of tea) which she held in trembling hands while she stammered out her story. Her friend, Bethan, and her mother both listened silently until she had finished.

Bethan's mam nodded her head slowly and said seriously, 'Ellen bach, what you have seen seems to me to be the Ci Du, the Black Dog of Death. He only comes when there is a death, and that is what you will be hearing of soon, cariad,'

Bethan turned on her mam, and told her to shush with her old wives' tales, Ellen was shocked enough and didn't want to hear news like that.

The old lady just looked at Ellen and went on nodding her head. When Ellen had gathered herself together, Bethan offered to walk back home with her. 'If the dog has gone, I'll come in and stay with you until Wil gets back,' she said.

'He won't be back tonight, he's gone fishing off the Point,' Ellen replied, 'but I'll be glad of your company back home.'

They set off, but as they neared Ellen's house, she clutched her friend's arm nervously. There was no dog at the gate, indeed, no dog anywhere about, so Bethan stayed for a little while, then said she must get back to her mam. 'You'll be alright now, Ellen bach,' she said, throwing her shawl over her head, but if you feel afraid, come straight to our house.'

They exchanged good nights and off Bethan went, as Ellen bolted the door.

Her husband Wil never returned from his lonely fishing trip near Point Lynas. His body was washed up three days later, and it was presumed that he had slipped on the weedy rocks whilst casting, fallen into the sea and been washed away by the swirling currents. So the Ci Du was right.

This story was told to Walt (my husband) by Mrs Janet Pritchard at the Dinorben Luncheon Club, it impressed him very deeply as he too has seen the Black Dog. I've attached that story to this one, as I was there at the time.

I hope you enjoy both versions.

BLACK SHUCK

Ghost dogs have been known world-wide for hundreds – if not thousands – of years. Their names vary in the British Isles, legendary names handed down the centuries by the people who lived locally.

In Yorkshire it is known as the barguest with shaggy hair and eyes as big as saucers, Anglesey has the Ci Du.

In the Isle of Man, the Moddy Dhoo, or Black Dog, repeatedly haunts Peel Castle. Lancashire calls it Thrasher, by the people who live near the coast, so named because of the noise it makes walking over the shingle of the beach.

Elsewhere it is just called the Black Dog but everywhere it is recognized as the foreteller of death.

Derbyshire boasts Black Shuck, who haunts lonely roads and lanes, and as a child I hadn't any clue what Black Shuck was.

As a youngster in Derbyshire, I was allowed to go to the village on Saturday evening to a local cinema.

Not exactly an Odeon, the wooden floor was completely carpetless and people stamping up and down the aisles were loudly shushed by an irritated audience, because the noise interfered with the ancient sound track mechanism.

Sometimes the dialogue became almost inaudible, until the entire audience was leaning further and further forwards in their seats, desperate to catch the words. Eventually the cinema looked like an Eastern mosque, everyone bent forward in the act of worship.

When (and if) full power was restored and the film once more became a 'talkie', there was a concerted sigh of relief, and rows of tense people leant back relaxed, as one.

In bad weather, the staff were allowed to bring their push-bikes in and lean them against the walls, and it was quite common for a latecomer, entering in the dark with eyes glued to the screen, to fall over a bike with a crash and a muffled curse, and be loudly shushed by the audience.

To me, it was a palace of dreams, even though it meant a three mile walk to get there and the same back.

I always went to the 'ghostly' films, and usually, when we were all trickling out at the end, a farmer's lad I knew, knowing how far up the valley I had to trudge, would yell out:

'Hey Bunty – watch out for Black Shuck on Elnor Lane!'

I hadn't got a clue what or who Black Shuck was, so I asked one of the local farmers, and he said it was a big black ghost dog that haunted the lane, and his (the farmer's) great-grandad had told him it had always been known as an omen of death.

After that bit of chilling information, I walked home on dark nights a lot faster up the two mile stretch of that lonely lane!

I had a torch for when it was very dark but I never knew whether to switch it on in case I saw Black Shuck, or leave it off – in which case I might fall over it. I always ran like mad past the cemetery, averting my eyes from the dim white glow of the headstones.

Nervous I may have been, but I still tramped most Saturday nights to the cinema.

Years later, when I had married a man with a fine technical brain, a qualified engineer who was a very analytical thinker, I used to tell him about ghosts, portents and mysterious happenings.

Of course, he didn't believe in ghosts. He was very kind and listened to my improbable tales with interest, not deriding me at all. I think he humoured me.

Anyhow, years later, on a lovely warm evening in June, we were strolling along Elnor Lane back home.

The lane dips where it meets the Valley road and meadows stretch along both sides, giving uninterrupted views.

Deep in conversation, we both happened to look ahead and saw a dog approaching.

It was large and black, the shape and size of a long-haired collie, and it was trotting quickly towards us, mouth open and pink tongue lolling.

Now, in a sparsely populated farming valley, everyone knows which dog belongs to which house or farm. This one I didn't recognise, and it had that wild-eyed look that dogs who are lost wear.

We stood still as it came closer.

'I don't know this one,' I said to Walt, 'I wonder if it is a stray?'

Lost dogs worry me, I usually take them home and try to trace their owners. (I bet Walt's heart fell, he loves dogs but he's been saddled with finding lost dogs and returning them for years!)

I made a clicking noise with finger and thumb and said gently, 'Hullo sweetheart, where have you come from?'

I moved slowly towards it where it stood on the grass verge, I didn't want to scare it.

The dog stopped with one paw upraised and stared at us. I took another step forward and it turned its head from us to the wall – then with one bound it leapt to the top, paused to look at us and jumped down the other side.

Now this wall is about four feet high, dry-stone with a coping of slanted narrow stones on its top. It is the boundary wall of a bare pasture, sloping gently downwards to the main road. The pasture is about 150 yards wide and roughly three acres long. It is completely bare of any vegetation except the close-cropped grass and is enclosed on three sides by the same height of wall.

We shot across to where the dog had jumped over.

'Oh Lor,' said Walt. 'I hope it doesn't run onto the road!'

We leant over the coping stones and gazed down the field. It was empty.

Walt leaned further and gazed along the wallside in both directions, in case the dog was crouching under it. No. Apart from a tall young sycamore tree at the other end of the field – there was nothing in it.

That dog could never have crossed the field in the time it took us to look over the wall.

The roadside wall was the lowest. Two feet high, with a single wire strand above – we could easily see over it, and the road was in full view. We stood and stared, swiveling our gaze from one end of the empty field to the other.

The dog had simply vanished.

'It's just disappeared,' Walt muttered, 'it couldn't have crossed in that time – where's it gone? This is crazy.'

He stared – looking just as baffled as I did.

'Gone into thin air – one minute he was here – the next –'

Then it hit me.

'Black Shuck!' I said.

'What?'

'Black Shuck – that's what it was – that's what they used to tell me,' I gabbled. 'I didn't believe them then, but it's true!'

'What?' Walt asked again, gazing abstractedly around as if he could make the dog appear again.

Suddenly, I remembered something else.

'Someone's going to die,' I said.

Walt was still trying to grapple with the unexplainable vanishing dog, and this last bit of information was too much.

He was very silent on the way home, as I told him what I knew about Black Shuck. He looked a bit dazed, then said 'I can't believe it, but it looks as if I've got to. There was absolutely no chance of that dog crossing that distance in the time, nor was there anywhere for it to hide, so that leaves no explanation. It could *not* have been a living animal, so I've got to accept it was your Black Shuck.'

Next day, I was just carrying the tea-tray into the sitting room, when Walt, who was facing the window, gave a startled exclamation.

The window sill there is about five feet higher than the garden, and only tall people can be recognised coming along the path beneath the wide window to the front door.

Following his gaze, I saw a bunch of bright purple and green feathers, moving along the bottom of the window towards the front door.

'Janet Jago's dead!' we said in unison.

Miss Jago was an elderly spinster who lived just down the hill from us, in a large Victorian house surrounded by woodland. She was very wealthy and very mean.

She always sat close to a blazing wood fire made of orange boxes which she had broken up and piled at the side of her chair. Every now and again she would hurl some onto the fire.

The room smelled of cats and singed carpet. Her house was full of antique furniture and elegant tarnished Georgian silver. Everything was covered in a thick layer of dust, and the house was incredibly dirty.

Miss Jago was looked after by a widow called Nellie, who was her unpaid companion. Nellie was provided with bed and board, in return for which she did a modicum of cooking.

We had bought some land off Miss Jago, who was a hard-headed Yorkshire businesswoman with a great sense of humour.

Not long before, we had been to see her and taken her a box of peppermint creams, which she loved. Nellie had been sent upstairs to vacuum the bedrooms, and Miss Jago opened the chocolate box and hid it down the side of her chair, as she stuffed four creams into her mouth. It was impossible to hold a conversation, so we listened to Nellie vacuuming the room above us.

We could hear the motor running but no movement. Miss Jago cocked her head sideways, and glanced at the ceiling. 'She thinks I'm daft,' she said indistinctly, her cheeks bulging. She leaves that running so that I think she's busy – not at all, she's either rooting through the drawers or trying on my new hat."

She swallowed loudly, then suddenly gave us an impish grin. 'She fancies herself in that hat.'

The two women disliked each other heartily, but they needed each other. Miss Jago, stout and red-faced, was not in the best of health and relied on Nellie.

Nellie needed a home, and Miss Jago had told her that in the event of her death, Nellie could live in the house for the rest of her life.

We heard her slowly descending the stairs, carrying the vac.

'Watch this,' Miss Jago said, giving us a sly wink.

'Nellie,' she shouted, 'bring my new hat down to show Bunty and Walt.'

We could hear grumbling in the hall about having to traipse back upstairs. Miss Jago rapidly shoved another handful of chocolates into her mouth, and chewed greedily before Nellie came back.

A minute later she appeared bearing a striking confection. It was a blue velvet hat, wide brimmed, the crown covered in what looked to be a nest of white netting. On top of this sat an artificial tropical bird, an eye-aching welter of vivid purple and green feathers.

'There,' said Miss Jago with satisfaction, 'what do you think of that?'

'Wow,' said Walt, 'it takes your breath away, that really is some hat!'

I nodded vigorously, unable to speak, wondering secretly if maybe she was colour blind.

Nellie was gazing at the hat with covetous eyes.

'It suits me better than her,' she said, 'I want to borrow it for my son's wedding in June.'

Miss Jago snorted.

'Huh – over my dead body,' she said, 'take it back up again.'

All this had happened two months before, since then Miss Jago had suffered a stroke ,which confined her to bed. We had been to see her twice, her speech was impaired but her sense of humour was still intact.

All this flashed through our minds as the garish feathers floated past our window.

I opened the door. There stood Nellie in her best coat, Miss Jago's vivid hat perched firmly on her head. She was trying to look mournful but couldn't disguise the glee in her eyes.

Miss Jago had had another severe stroke and died at 4 pm, the previous day, approximately the time we saw Black Shuck. Nellie was going around the valley, ostensibly to break the sad news, but, in reality, we knew she wanted to show herself off in her new finery.

A few days later we attended Miss Jago's funeral, but we were not invited to Nellie's son's wedding. She did, of course, wear the hat.

So much for Black Shuck. Walt is now a believer!

17
WHO KNOWS HOW?

The gentleman who told me this story wishes to be known as Mr Lands. A professional, retired man who has lived on the Island all his life and is popular and well respected.

To begin with, he told me about an 'OOB' (out of body) experience he had had as a young sergeant in the last war. The sergeants were billeted in part of an old hospital and some, like himself, were fortunate enough to have their own rooms.

One particular night he went to bed feeling very tired and promptly fell asleep. He hadn't had anything alcoholic to drink. As he slept deeply, he felt a disturbance within his body and something detached itself from him and floated upwards to the high Victorian ceiling, then bobbed slowly along towards the window.

To his horror, he realised it was he himself that was floating and looking down, he could clearly see his body fast asleep in bed.

By now, Sergeant Lands realised he could not control his movements and he told me if the window had been open he most certainly would have floated through. He could see everything in the room from his elevated position and when he turned his head he noticed a lot of dust on the top of the big windows. Also, thick with dust, and looking as if it had lain there for some time, was an old wooden handled screwdriver, forgotten years ago.

His fear at being helpless and out of control became so intense, it must have activated whatever held him suspended (soul, spirit, what?) that he felt a soft swooping sensation and he returned to his physical body on the bed. There he lay, his heart hammering and his pulse racing, but now in control again.

Next morning at breakfast, he told two of the other sergeants (even though he knew they would scoff) because the experience had left a deep impression on him. Scoff they did, demanding to know how much he'd had to drink and that he was dreaming etc., but he was adamant, telling them about the screwdriver lying on the top of the window frame.

'I bet you £1 that if you got up there – you'd find it alright,' he said.

'Right – you're on,' said one of his mates. 'Let's get a ladder.' Which they did and one scaled it while the others held it.

'I had a funny feeling,' Mr Lands told me. 'I wondered if I had dreamt it after all – I'd feel such a fool – and lose two quid – but I was sure I was right.'

When Sgt. Thomas reached the top, he looked at the ledge, then down at the watching men. Slowly, he took something off the ledge, then climbed back down.

In his hand lay, not only an old screwdriver coated with dust, but also two large dirty screws. They all stared hard at the objects, there was no doubt about the layers of dust, they hadn't been moved for years.

'Well, blow me,' muttered Thomas, (only he didn't say blow!). 'How did you do it?'

They stared at Sergeant Lands, but he just winked and held out his palm.

'I have thought about that ever since,' he told me. 'I don't know what happened, I haven't a clue, but I don't want it to happen again. It's just a mystery to me.'

Many years later, Mr Lands was a widower and his son died tragically in an accident. Mr Lands was devastated, as he said, and he didn't know how he kept going.

On the day of the funeral, he got ready automatically (he was in a daze) and when it was time for his nephew's wife to pick him up, he suddenly remembered that he had no handkerchief and made for the front bedroom where they were kept. He hardly used this room as he slept in the back.

As he said, 'As I pushed at the front bedroom door, which usually opens easily, I found that it would hardly open, something inside the room was jamming it. You see, there is a dressing table slightly to the left of the door. If any of the drawers are open, they fill the small gap between the room door and the dressing table and it is impossible to push the door wide open.

With a lot of difficulty, I managed to squeeze my hand through and groped around to find the front of the drawer, pushed it closed, and then I could fully open the door and walk in.

A photograph of my son, which stands on the dressing table, lay flat on its back, even though I hadn't jolted the dressing table. My relatives told me I must have forgotten that I had opened the drawer, but I pointed out that if I had left it open, I wouldn't be able to get out of the room.

This puzzled me a lot, I wondered if the dressing table had tilted somehow, letting the drawer slide open, so I got my spirit level and laid it on the table. It was dead level. The gap between the open drawer, and the opening of the room door was at the most six inches – it was impossible for anyone to enter. The windows were closed and locked from the inside, and had not been forced. Apart from the picture lying face upwards, nothing was disturbed.

This happened on the day of my son's funeral, and a few weeks later, when I was feeling very sad and depressed, it happened again.

I remember it was a lovely spring day, but everything seemed so pointless now that I was all alone. I just couldn't settle and I was prowling aimlessly around the bungalow.

Once more, I found I could not get into the front bedroom, so I went and got my digital camera and took a photograph of the open drawer, through the small gap between the door and the drawer, and I have the photograph here if you wish to see it. I wonder if it was my son indicating that I mustn't grieve, he was still near me? I don't know.

18

HORSEMEN AT LLANACHERMEDD

One evening in winter a few years ago, Miss Nia Jones (as she has asked to be known) was driving along in her car with her friend Mary. They were going to a small church on the A5 side of Llanachermedd for a friendly Sunday get together. Usually the evening began with a few hymns and then a good gossip with their friends, and ended with tea and light refreshments.

As it was quite dark, a moonless starlit night, and Mrs Jones was driving with her headlights on.

She was approaching Llanachermedd and just before she got to the 30 mph zone or, as she explained it, past the old buildings, once the workhouse and now a thriving gallery for picture-framing, gifts etc., the following occured. I will let her explain in her own words what happened.

'We were going down the slight dip there and chatting away when I suddenly saw something that made me slap my brakes on hard. Right in front of the car, and showing up vividly in the headlights, a group of horsemen suddenly shot into sight, right across the road in front of us. Then, at full gallop, they leapt over the hedge in front of us to the right and disappeared across the field.

It all happened so quickly, I couldn't believe me eyes and I said to Mary, "Did you see what I saw?"

"Horses," she said blankly.

I put the handbrake on and switched off the engine, and for a moment we just sat there. There was nothing on the road, no traffic, which was a good thing because I hadn't pulled into the side, just stopped dead in the middle. Anyhow, we didn't say anything to anybody, but we must have seemed quiet because we were preoccupied by what had just happened. I was trying to remember all the details and I know Mary was too. It all happened so quickly. As far as I remember, they all wore tricorne hats – you know, like highwaymen's hats – Dick Turpin style. I don't think they were soldiers, they weren't in uniform, they weren't all dressed alike in the same colours.'

She was silent for a minute, thinking deeply. Then she started again.

'They didn't have long coats either, they just came down to the horses back, and they seemed to be very full in the skirt part, you know, down from the waist.

We talked about it on the way home and we were a bit scared when we got back to the spot, but there was nothing to be seen.

Mary had noticed different things. She said they all had something long across their saddles, she didn't know whether they were old fashioned guns or swords, it was all over so quickly, but she did say the road wasn't a road so much as a track with grass in the middle.

Also, we had this vision of them all jumping over the hedge, there must have been about twenty of them, but they were gone in a flash. Who they were and where they were going, I don't know, we've never seen them since, and we never told anybody else in case they thought we were nuts.'

From Nia's scant description it sounds as if the horsemen were in eighteenth-century garb, tricorne hats, tight-waisted, full-skirted jackets, whether they were soldiers or civilians, Nia couldn't tell, the sightings only took seconds, then they were gone.

There were so many skirmishes and battles in that area later in the eighteenth century, no one could hazard a guess what their quest was, unless someone can shed any light on the subject?

19

THE COLLARLESS GHOST

Mr Ian Clare, who gave me the Wylfa story for *Haunted Anglesey*, had this one for me.

This is how he began:

'It happened a few years ago – er, I'm trying to get a time-scale here – maybe ten years ago, that's when it first started.

I got into the pleasant habit of walking down to the local pub some nights, to meet friends and catch up with all the news, it's exactly a mile from my front door to the "Cefn Glas".

I was walking back one night in winter, quite a cool night – I don't drink much, but I'd been talking in the pub, and it was late, getting on for half-past eleven. I'd probably got about a third of the way home, when I became conscious of someone walking ahead of me. I didn't take any notice because it was a dark night, with a few people about, then suddenly he wasn't there.

It happened two or three times like that, him walking along in front and me behind, then he would vanish. So I started to take a bit more notice.

He wasn't always there, I didn't see him every time, but I started to look out for him. This lane runs from LIansechell to Mynndd Mechell, and after a while it became obvious that he was appearing out of a little old smallholding called Simdde Wen (White Chimney) which, funnily enough, was the same name as the old house at Wylfa, and disappearing at a farm about quarter of a mile further on called Bwchanan.

I thought it was someone who worked at Simdde Wen and lived at Bwchanan and was going back home. So I did a bit of enquiring – I knew the feller who used to live at Simdde Wen, I once worked with him at Wylfa, he retired years ago, so I said to him, "Hey Will, who's the old feller who walks up the lane late at night, and goes to Bwchanan?"

He just looked at me blankly and said "What?"

I didn't press him, because obviously he hadn't got a clue.

Then the coincidences started to occur. To begin with, it would go for weeks without him appearing, and then suddenly one night he would be there.

I realised it was only around the full moon that I saw him, and it was the only time I would see him, and up to now I thought he was an ordinary feller. Another thing, he was always dressed the same.'

I asked him then, 'Was he always walking, or was he standing waiting for you?'

'Oh no,' said Ian, 'he was always walking – walking in front of me and when he got to the gate at Bwchanan he would turn around, look back up the lane and stop for a minute before he opened the gate. I could see him very clearly, what he looked like and how he was dressed. It was only then I realised about the moon, because the lane is very dark, sometimes so dark you can't see your feet but you get used to knowing where you are by the bushes sticking out of the hedge. I could swear he wasn't on the lane on any other nights, only when the moon was full. Then I got a good look at him. Little feller he was, fairly old, about five foot two or three, with a dark suit on. What I couldn't understand was, why was he always wearing a suit and not working clothes if he was a farmhand? Always a dark suit with a white shirt and no collar, you know, the detached collar shirt, and a flat cap.

You're sure it was a suit, not working clothes?' I asked.

'No, it was a suit,' he said definitely.

'Probably his best rig?'

Ian nodded. 'Yeh, his going to funerals suit. I asked at the pub, but the landlord had only been there twelve years, so he didn't know, but one of the men, one of the Bwchanan family, was in one night, so I asked him. He looked very surprised and stared hard to see if I was pulling his leg, and then he said, "What did you say?"

So I asked him again who the little old feller was who I'd often seen appearing out of Simmde Wen and disappearing at the Bwchanan farm late at night.

"So you've seen him?" he asked. After explaining what I knew, how he was always dressed in his best dark suit and a shirt with no collar, he nodded. 'I know him but I didn't know he was still walking. I'll tell you about him.'

He took a swallow of his pint, then said, "There was a feller named John Rowlands who worked at Simdde Wen old farmhouse – before my grandfather's time. My grandfather always told the story of John Rowlands. He was a bit of a character, always knew his own mind, once he had made it up wild horses couldn't make him change it. Apparently, he hated shirt collars, in those days they were detachable and you put them on with a front stud and a back stud. According to the story, when he was a very young man he was getting dressed up one day to go to the fair and he just couldn't get the studs right, so he ripped the collar off, slung it across the room and swore he'd never wear a collar again, and he never did. Nobody could get him to wear one, however hard they tried, he absolutely refused to wear a collar, whether he was going to a wedding, a funeral, or what. Didn't matter how dressed up everyone else was, he always appeared in a clean white shirt buttoned up to the neck, but never ever a collar and tie."

He took another swig and said, "I've heard about people seeing him on the lane at night but I've always thought they were kidding – John's been dead for years and years, long before any of us were born, but the story does say he was only about five foot three and the people who have seen him do describe his flat cap and dark suit." He grinned at me, "You've seen a ghost, Ian!"

Well, I thought about this, it seemed ridiculous, so next time I saw him I spoke to him.'

'Did you catch up with him?' I asked.

'No I called to him from where I was, a bit behind him. I said "Syd ydach chi, Mr Rowlands?", but he absolutely ignored me, just walked on to Bwchanan, looked

back down the lane (definitely no collar) and disappeared through the gate – I don't think he even opened it. I've spoken to him many times since, but he always ignores me. I haven't seen him lately, but I know he will suddenly appear in front of me, and when I call he'll ignore me. Perhaps he doesn't hear me, he must be in a different time scale to me.

The other thing is, I can never catch up to him no matter how hard I try, but he certainly hasn't got an "atmosphere" around him, he's not at all frightening, just going about on his own business, as he did when he was alive.

I'm very curious, I haven't found out any more about him, but I keep trying. I've often asked in the pub, course you get your leg pulled don't you – try drinking the mild instead of the Guinness! Anyway, it puzzles me, especially as people can put a name to him – so he did exist.

If I get any more details, I'll certainly let you know.'

20
WOMAN IN THE WINDOW

In *Haunted Anglesey* I wrote a story given to me by Mr Jack Longman of Cemaes, called 'Woman in the Well'. It was about a well in a field below a farmhouse which lies a few hundred yards out of Amlwch on the road to Wylfa Power Station. Apparently, the apparition is that of a woman who lived in the farmhouse and drowned herself in the well. The well has been capped with a concrete lid and was discovered by Jack when he was looking for a septic tank.

I asked at the end of 'Woman in the Well' whether anyone knew of any more details, and Mrs Jenny Acton kindly phoned me when she had read it.

This is what she told me:

'In 1981 we had moved here from Birmingham. My older brother and his family were already here, and they were going to move into a rented farmhouse, whilst my Mum, myself and one of my other brothers were staying in a caravan.

There was quite a lot of work to be done on the house, so I decided, about half-past five one evening, to go across and see if I could help.

It was a hot July day, very sunny, and as I got near the house I could see someone moving about in one of the bedrooms. I couldn't see whether it was a man or a woman – they were too far back from the window, but it was definitely someone.

I went through the gate and down the path to the door. I tried the handle but it was locked, so I knocked. No response. After knocking about three times, I thought "they can't hear me, I'll go round to the back". To get there, I had to retrace my steps and go back up to the front gate. As I turned to close it, I looked at the house and I could still see movement in the bedroom, so I went down the side and round to the back door. This was locked as well, so I started knocking and calling my sister-in-law.

"Linda, it's me," I yelled, "let me in!"

No one answered, so I turned to go back home, very puzzled. I looked back at the house and saw the figure again, it was a woman but not Linda.

It was flitting very quickly to and fro in a very queer way, almost like flapping, and it made shivers go up and down my back. It was female but certainly not Linda.

Then it stopped flitting about, and just stood in the window staring at me, which was worse than ever.

It was such an eerie feeling, I knew it wasn't human, it had no features that I could make out, just a blob for a face, but I knew it was staring at me. As soon as I realised it

wasn't human, just a lumpy shape, I legged it! I never told anyone about this incident, I thought they wouldn't believe me anyway.

Then my brother and his family moved into the house. Things were OK for a few days, then the boys began wandering downstairs, half asleep, late at night, and they started complaining about a lady being in their bedroom, and she 'looked funny'. At the time they were all little, aged two, four and five, and they all slept in the front bedroom. Linda told them they had been dreaming, took them back upstairs and tucked them in. The room was always empty when she went back.

This happened about three times, and the last time the five year old was crying and said they weren't making it up, there really was a lady there and she'd leaned over them in bed.

They were very reluctant to go back to their bedroom, but Linda said she would read them a story and stay with them till they fell asleep. They thought she meant she would stay with them all night, so, feeling comforted, up they went with her.

When they had left the room, I told my brother what I had seen in the window of that bedroom, and it made him think because he doesn't believe in ghosts. I think he realised then that the boys had been telling the truth, especially since I had seen the same thing.

When Linda came down later, we all talked about it, apparently whatever it was had been appearing to the children more frequently, and even though the adults hadn't seen it, Linda did admit that there was a "funny feeling" about the room and she was worried for the boys' sake.

So they decided to ask the advice of the Rev. Emlyn Richards, of Cemaes, and after telling him all the details of the haunting he told them that if they wished he would gladly come to the farm and perform the Service of Blessing on the house.

They were most grateful, and the service was duly carried out, with the result that the atmosphere became calm and restful, and the boys slept in peace.

The figure has never been seen in the house since, but still haunts the road outside, and the field which leads to the well. The hauntings are still continuing.

Anyone who has read *Haunted Anglesey* may recall that Jack Longman was looking for the septic tank of a house called Morelais when he discovered the well.

Morelais was a fairly new house (built between the wars) and the farm predates it by a couple of hundred years.

Alex, a boy who lived there when the well was uncovered, lived at Morelais and is a great friend of Jenny's son and about the same age. He told Jenny that every night, late on, whilst the family were sitting in the kitchen, the most tremendous thud was heard from the bedroom above the kitchen, 'as if,' said Alex, 'someone had dropped a bag of potatoes on the floor.'

At first, they had all dashed upstairs to see what it was but everything in the room was always normal, so after a time they gave up looking for an explanation and just accepted it.

So, another house which contains another unexplainable mystery – how many more are there on the Island?

21
BULKELEY ARMS, BEAUMARIS

The Bulkeley family of Anglesey was very powerful as far back as the fifteenth century, being wealthy landlords and politicians. When Victoria was crowned queen in 1837, the Bulkeleys had already built and completed an elegant house on the straits of Beaumaris, (Beautiful Marsh) with superb views of Snowdon and the mountains.

The whole object of the venture was to invite the young queen and play host to her when she visited Anglesey, thus consolidating a privileged position in society.

The house was richly furnished and staffed with many servants, the view from the windows was unsurpassed and the excitement intense when the young queen graciously accepted the invitation.

Her equerries arrived first with news of the queen's progress, and in the flurry of arrangements for a great feast to be prepared, little notice was taken of an old man who came to the servants' entrance, asking to speak to someone in authority. When asked his business, he said politely that he wanted to ask for recompense – he was a fisherman who had lived in a poor cottage, between the Bulkeley's new house and the Straits. This cottage, like many similar ones, had come between the house and the magnificent views from the windows. So, rather ruthlessly, the Bulkeleys had them all knocked down, and the families who had been ejected had asked the old man to come and plead on their behalf. He was summarily sent packing, but before he left, he told them what the future held for the Bulkeley family.

First, he said preparations for the royal visit were in vain, the young queen would not stay with them. Next, he told them that their ambitions would come to naught, for the power of the family would pass away before another hundred years went by.

This curse was jeered at, but, to the great dismay of the Bulkeleys, Queen Victoria was warned that there was an outbreak of smallpox in Beaumaris, so she and her grand retinue bypassed the Bulkeley's grand house, and went to stay at Plas Newydd, the home of the Marquis of Anglesey, much to the fury of the Bulkeleys, as there was no love lost between the two families.

However, fourteen years later, the Queen travelled again to Anglesey, and came to stay at this opulent mansion, much to the satisfaction of Richard Bulkeley.

The old man's curse eventually seemed to come true as the power of the Bulkeleys did indeed decline, for eventually the magnificent house was turned into a fashionable hotel for rich families and was called the Bulkeley Arms.

The room most in demand by the guests was No. 16, the room occupied by the Queen, although that particular room isn't haunted.

A young man in early nineteenth-century evening clothes is only occasionally seen, but his voice is often heard as he drifts about the hotel, apparently searching for his lady.

His querulous call, 'Rebecca, Rebecca?' echoes sadly along the halls and corridors.

Also, before the cellars were modernised and converted, bar staff who went down to work there were frequently startled by the sound of low, coy laughter in the dark corners.

'Definitely a girl's laugh',' an ex-barman said. 'She sounds as if she is flirting with someone – and enjoying it!'

Could this be the errant Rebecca?.

22

WHO WAS IT?

Ellen said to me:

'I was having my day off from Ysbyty Gwynedd (Bangor Hospital) where I work as a nurse, and I was idly staring out of the window at the grass blowing on a windy March day, not thinking of anything really.

I was fit and well and very happy because I had just moved into my first flat, after I'd 'fled the nest'. The flat is the bottom flat of an old farmhouse which has been converted into two. I'd been there about two weeks, before the event I want to tell you about.

My mam was coming to tea, and I decided to make some scones – I love cooking. So I started to collect my baking things, I got my scales down first and put them on the worktop. They're not new ones, my mam has had them passed down to her through the family. They're heavy, big brass ones that I polish every week.

Anyhow, I lifted them down and put them on the worktop on the left-hand side, while I got the rolling pin and all the ingredients out. Just then the phone rang and I went through to the lounge to answer it.

When I said "Hello" there was no answer, just that buzzing noise you get when the line is engaged. So I dialed 1471 to see which number it was that had tried to ring me, and the automatic answering voice said 'You were called yesterday at...' and then gave me details of a call I'd had the night before. I was a bit puzzled, but hung up and went back to my baking.

I stopped in the kitchen door and blinked.

The heavy brass scales that I had lifted down were back on the shelf!

The first thing I thought was I was going potty! Well you do, don't you?

I *knew* I had lifted them down, but how could I? There was no one else in except me, and scales can't move themselves. Or can they? Later on I began to wonder.

The next thing happened about a week later, I've got a little radio that I carry about from room to room, so I can listen while I'm working. One night, I'd taken it to bed and listened to a play before I went to sleep. When it was over, I switched it off, and the bedside light, then turned over and dozed off.

In the middle of the night I was wakened up suddenly by a great noise of music – foreign music Indian or something and I sat up with a start. The overhead light, which I never use, was on, and I looked about me, still half asleep. As I did, the bedroom door

swung shut. I jumped out of bed and ran to open the door. No one in the corridor, everything normal.

Back in the bedroom, I went to switch the radio off, it was very loud and I was afraid it would waken Mrs. Taylor up, she was a very nice woman, a widow who had the upstairs flat, and her bedroom was above mine.

But where was the radio? Not on my bedside table where it usually stood, I looked around and couldn't see it anywhere, so I traced the noise and found it.

Under the bed!

By now I was a bit scared, I rescued the radio, switched it off and put it back in it's place. Then I sat on the side of the bed and thought about what had happened.

First, I'd seen the door closing when I sat up – but who had opened it? I always slept with it closed. Then the top light – I never used that, but it was on. And the radio, under the bed and on a foreign station – I always listen to Radio Four.

First thought was, I'd been walking in my sleep, there's a first time for everything – hold on I'd seen the door closing and I wasn't asleep then!

By now I was wide awake, so I piled all the pillows up behind me, and spent the rest of the night sitting up with the lights on. I didn't sleep at all and next day I was fit for nothing. Now I was aware of something strange I began to notice what else had happened. Little things like my cat not wanting to stay in, sometimes she'd be outside, miaowing to come in and when I opened the door for her she'd come in happily, then stare at something behind me and shoot out again before I could close the door. I never could see anything, even when she woke up in the chair, stared across the room, bristled all her fur up, then shoot under the TV.

After a few weeks of this, I'd got very nervous and jumpy, so the doctor gave me some sleeping pills, because he thought I was suffering from overwork. Was I glad! I got a few nights good sleep in and felt a lot better.

Then one night, when I was in a sound sleep, I suddenly shot awake. I could feel something flapping around my face.

It was very soft and feathery, like a bird's wing and it moved very gently over my head and face. I went stiff with fright – then I dived under the covers. I didn't go back to sleep, I couldn't, I just lay there waiting for something else to happen, it didn't but I was jolly glad when it came light.

Two days after, it was my day off so I had a lie in until 9 am. Mrs Taylor's alarm clock upstairs woke me up, it was quite loud and it went on and on for ages, I wondered why on earth she didn't switch it off. Then there was a tremendous crash, and the alarm stopped.

Later I met her coming downstairs taking some rubbish out, she said she'd just made a panad (cup of tea) and would I like one. When we were drinking it, she said:

"Do you know Ellen, such a funny thing happened this morning, I had breakfast, did the washing up, and went back to make my bed and there was my alarm clock on the floor, smashed into little pieces. Not just broken, really smashed, and it was across the room from my bed."

"I know" I said, "I heard it ringing and ringing for ages, I wondered why you didn't switch it off, and then there was a tremendous bang and it stopped."

She sat staring at me.

"You heard it ringing?" she said.

I nodded.

"But I hadn't set it, I hardly ever use the alarm, unless I'm going somewhere – you couldn't have heard it."

I assured her that I had. We worked out that she was doing the breakfast dishes about the time I heard it go off, and she hadn't heard a thing, although all the doors were open and the flat isn't that big.

So we compared things then, lights being on in empty rooms, knocking at the door and nobody there, all sorts of little things.

In the end we decided it must be a poltergeist, as neither of us had seen anything. So although we still felt uneasy, we weren't scared because poltergeists never hurt anyone.

Things went on like that for a bit, and then Mrs Taylor's daughter brought her fifteen-month-old baby boy to stay with his nein (gran) for the weekend. He was a lovely, jolly baby, and I helped them to bring the cot out of the car and set it up in the back bedroom. He'd always been used to sleeping on his own, and he was no trouble.

She'd brought him on Friday and was going to collect him on Sunday when she came back from her weekend away.

Mary (Mrs Taylor) absolutely adored him, and I could hear her laughing all the time upstairs.

Then, in the middle of Saturday night, there was a soft knocking on the front door of my flat, I was fast asleep and when I woke up, I nearly had a heart attack with fright.

Then I heard a voice.

"Ellen, wake up it's me, Mary."

Was I relieved! I put my light on, grabbed my dressing gown, and padded to the door. There stood Mary in her nightie.

She put her fingers to her lips to hush me then she said, "Come and look at this".

So we crept upstairs to her flat and tiptoed along the landing to little Jack's bedroom. He had a little battery Mickey Mouse night-light on, which stayed on all night, and the door was always open, so we could see into his room quite clearly.

Mary had looked in at him as she went to bed in the room next door, and he was fast asleep with his arms over his head.

She had been awakened by the sound of his laughter, and little squeals of delight, as if someone was tickling him, and gurgling baby talk, mixed up with the few little words Jack had learnt to say.

When we looked in, he was standing at the end of his cot, laughing and talking with his arms raised to be picked up, and his chubby little fists opening and closing.

He was talking to someone or something in the corner of the room, on the same side as the door, which was open, and prevented us from seeing into the corner.

So I slowly tiptoed two steps inside the door, and peeped around it. Nothing there. As I did so Jack stopped laughing, and looked puzzled, still staring into the corner. Then his little arms dropped and his face became a picture of disappointment. He saw us then, and his face fell even more. He opened his mouth and let out a howl.

Mary rushed in and picked him up, but he twisted in her arms and shrieked, lifting his arms to the empty corner and screaming and struggling as she carried him out of his room.

We took him into the living room, but he would not be comforted, sobbing pitifully and trying to push her away.

I made her a cup of tea while she walked about with him in her arms, rocking and shushing him until he finally became drowsy and sleepy. Then she laid him on the settee, and I went for his blanket.

I had to force myself to go into his room, but there was nothing in the corner, nothing in the room, all was still and calm.

We whispered to each other over a cup of tea, we were emotionally exhausted.

"Well that's it," Mary said with a deep sigh, "if he can see it, then it isn't a poltergeist."

"Whatever it is," I said, "it doesn't want to harm him," I said, "he seems to like it."

"It doesn't want to harm him *at the moment*," Mary said grimly, "but what about the future – who knows?"

I felt a shiver like cold water going down my spine. I looked at Jack's tear-stained face, then looked around the normal looking room and wondered what else may be in there, watching and listening to us.

"I'm not staying here in this haunted place," Mary said finally, "I'm going to talk to Betty (her daughter) tomorrow and ask her to look out for a flat for me. I don't care where it is." We were silent for a moment or two, then Mary said, "Have you noticed the atmosphere in this house lately? It seems to be getting heavier somehow, as if something is going to happen.

Well, I'm not going to hang around to see what it is, I'm getting out of here as soon as I can."

I considered a bleak future coming back to a house devoid of any human life and made up my mind.

"Me too" I said, and meant it.

That's why I got this little cottage in Amlwch Port.'

When Ellen had finished her story, we sat and drank our tea. We stared in silence at the grey stone house on the hill, both wondering what eerie secrets it held.

23

BEAUMARIS PRISON

It has been haunted since the 1830s and this has been recorded by many people, both staff and visitors. Apparently, the phenomenon begins by a feeling of oppression and anxiety in the atmosphere of the condemned cell and gradually creeps through the building, escalating to an overpowering sense of terror.

At the same time, in the prison yard and beyond in the adjacent streets, there gradually grows a feeling of unrest and anger. This lies heavily, as if it is generated by a multitude of unseen people, whose attention is focused entirely on the prison itself.

On four separate occasions (the only ones recorded, there could be many more that have not) the following scene takes place.

From the condemned cell, along the upper corridor straight through the prison, a man is forcibly dragged, struggling madly, by four prison officers to a doorway in the end wall, which opens from the top floor and looks down on the prison yard.

As he appears the atmosphere becomes charged with anger, as if a great multitude below was growling and shouting in rage. Not a soul can be seen and although the prisoner's mouth shows he is screaming, the whole thing is conducted in an eerie silence. Then the whole scene vanishes and the shaken observer begins to doubt his reason.

After being told three different people's versions, I became interested enough to research the story and, putting together the pieces of information, this is what I believe causes the phantom scene.

The prisoner who was being taken to his death was one William Griffiths, the first man to be executed at the jail.

He was a native of Anglesey, a thoroughly bad man, but not in essence a murderer, as his victim was still alive when he was hung. This is his story:

William Griffiths was a ne'er do well and a bigamist. He hated work, was a petty thief and he was feared by many people. Big and strong, when he was drunk (which was often) he became belligerent and violent, never happier than when he got into a fight.

But he could charm the ladies when he wanted to, for example when he needed money, but affairs didn't last long. He tired of them very easily, as he did of his first wife. Nothing has ever been recorded of her, either her name or where she lived, only that one day he walked out on her and never went back. She was lucky. A few months later he married again, to a lady whose looks took his fancy, as did the few guineas that she had put away.

She rented a tiny cottage and worked very hard, going out every day cleaning and washing, saving up for her old age. Her new husband moved in and at first he was very attentive, wheedling and charming money out of her for his great passion – drink.

Soon, her savings were gone and as he had no intention of working, they had to rely on the few shillings she earned weekly, and it was then he showed the real side of his nature.

Neighbours began to hear heated arguments, and he would come storming out of the cottage with whatever money he could force out of her – on his way to the pub. They were too afraid of his foul temper and flying fists to interfere, even though they must have heard her screaming when he beat her, which was often.

One day, a row began which gained in noise and violence. Firstly, the neighbours heard him shouting and cursing, furniture smashing and then screams of pain from the woman.

As they listened, the screams ended in a horrible gurgling noise, the door was thrown open and he staggered out in a drunken rage, shouting obscenities at the goggle-eyed neighbours huddled next door on the step, and went up the road muttering to himself.

As the painful gurgling noise went on, the neighbours peered through the open door to see what was going on. Good job they did too, for a horrendous sight met their eyes. The woman was lying semi-conscious, battered and bleeding, trying desperately to breath around a great rough stick that had been savagely thrust down her throat with great force and was protruding from her bleeding mouth.

Far worse than that, she had been dragged to the fireplace and her head was wedged in the fire. Her long hair was burning fiercely and a few moments later she would have been dead.

They pulled her free, doused her blazing head with a wet towel, and gently removed the stick from her injured throat. Putting her to bed next door, they cared for her as much as they could and gradually she came round.

The law, such as it was in 1830, was informed, and William Griffiths was sought, caught and taken to Beaumaris Prison. His wife slowly recovered, although all her hair was burned off and her throat was so damaged it was weeks before she could speak and only then in a hoarse whisper.

Griffiths had certainly intended to kill her, in fact he never went back to the house, he thought she was dead and he tried to disappear.

His trial took place a few weeks later after his arrest, and his execution was to be the first to take place in Beaumaris, as the Prison had only been built for a year.

Learning that he might be accused of murder, Griffiths tried to get word to her that he was sorry for what he had done and wanted to see her. She went to visit him, and he was seemingly contrite, painting a wonderful picture of the kind of future they would have together if he got off – him working hard and looking after her, so she would never have to work again.

He was so plausible with his lies that the poor besotted woman believed him and promised to speak in his defence when he came to trial.

But even though she pleaded for him (she was the only one that did) it was to no avail, and the judge gravely intoned the death sentence.

Listening with a shocked expression of disbelief, Griffiths went very pale and his hands gripped the dock.

As the warders stepped forward to take the prisoner down, Griffiths suddenly erupted, shouting that it was an unfair trial and he had killed no one.

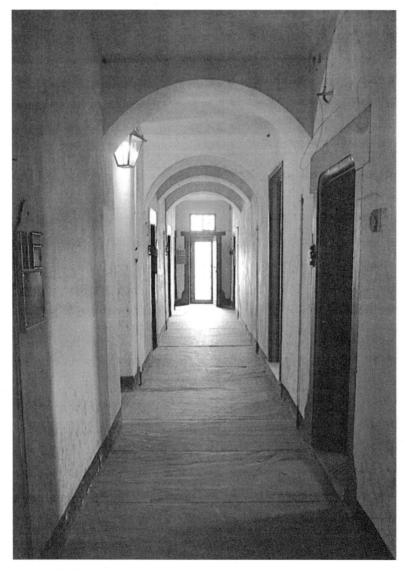

Beaumaris Gaol. The haunted corridor along which Griffith's screams are heard. He was dragged along here to his death. (Photo courtesy of Gwynedd Archives.)

He was roughly bundled away and the silent courthouse resounded to his cursing and yells, until they faded out of hearing.

During my research into this story, I contacted Mrs Mary Aris, MA, retired Principal of Education (amongst her many other positions) and she very kindly supplied me with the following facts:

'As the jail was so very new, they hadn't really thought out the mechanics of an execution, so they had to do a makeshift scaffold. To make things worse, the execution sentence was very unpopular locally, the people all seemed to be on Griffiths's side, mainly because at this trial his wife was there, weeping as she asked the judge to show

mercy on her husband. Of course, none of the public knew Griffiths for what he really was, a drunken, murderous and manipulative liar.

So unpopular was the verdict, in fact, all work for the execution was boycotted. No one would help to build the bridge from the upper floor of the prison, across the yard to the gallows, workmen had to be brought in from Liverpool.

Worst of all, the official hangman flatly refused to cooperate and the hangman from Chester had to be brought in.

We know from the jail records (Mrs Aris stated) that a wooden bridge with metal supports at the height of the upper floor door, through which the condemned man would be brought from the top corridor was about six feet too long, and it stretched right into the corridor – very makeshift. This bridge led to the scaffold which itself was suspended outside the wall.

It was outside so the populace could see it being carried out, all executions were in public until 1868.

The town of Beaumaris was agog with news of the sentence, every pub, shop and chapel was full of groups of people arguing for or against the verdict.

No – said some – he wasn't a murderer, the woman was still alive, he shouldn't be put to death.

Ah, but, said the others, if the neighbours hadn't acted quickly, she would have died, he wanted to kill her and thought he had, why else would he try to disappear?

People watched closely as the bridge to the scaffold was erected, then the scaffold itself, the sound of many hammers was very loud and most certainly the condemned man in his cell must have heard them every day.

The day of the execution dawned, cold and grey, and everything was ready. There now stood a bridge leading from a new doorway on the upper floor, across to the outer wall where the scaffold was suspended.

Each side, under the new doors, both the one in the top floor of the jail itself and the door to the scaffold in the outside wall, were metal supports for the bridge, and under the first floor door in the jail, two large metal hooks can still be seen, and they were the hooks from which the bridge was suspended.

By now, the mood of the townspeople was ugly, they had decided that the death sentence was wrong and folk from all over the Island had swelled the throng at the gates, an execution had never taken place on the Island before.

It was a huge, hostile crowd, queueing at the gates, and surging round the nearby streets. People who had houses in Steeple Lane, opposite the scaffold, rented out their upper front floors at very good prices to folk who wanted to be in at the death.

The authorities had become very uneasy at the mood of the townsfolk, they had stationed many javelin men (as they were called) around the scaffold to keep off the crowd in case they tried to stage a rescue, or even started a riot. There were enough javelin men to fend off the people whilst the executioner carried out his gruesome business.

The time arrived for Griffiths to be brought from his cell. People pointed excitedly as the new top doors in the jail were opened and Griffiths could be seen being led along the corridor in a group of warders.

He put up an incredible struggle, trailing his legs so that he was a dead weight, and fighting fiercely to get away from the warders.

At sight of him, a great angry growl came from the crowd, they surged forward, but the javelin men stood firm. They were not locals, but had been imported to the town (adding

The door leading to the bridge over the courtyard, and thence to the scaffold on the outside wall. Note the bolt on the outside of the door. The glass door is modern, while the right-hand door leads to a typical cell. (Photo courtesy of Gwynedd Archives.)

to the high expenses of the execution, according to the documents) and the people had to stand and watch as he was dragged, screaming and cursing, over the bridge.

Even on the scaffold, as the hangman prepared to put the rope around his neck, he tried to dodge away, his pinioned arms straining, but then his legs were strapped together, and though he fought to the last, there was no getting away.

Finally, the trap he was standing on was sprung and he fell to his death.

Not the humane way of snapping the third vertebrae down (as our old friend Albert Pierrepoint used to do, also studying the victim's weight and the length of drop so death

was instantaneous), but the long sequence of manual strangulation by the rope, which lasted for minutes and was a horrific sight to see.

The javelin men were alert as Griffiths writhed in his agony and slowly died. There was a long sigh, and a few sobs before the crowd fell silent.

It was all over.

On the anniversary of his execution, the air around the jail becomes oppressive and heavy, and folk become uneasy without knowing why.

But the emotions of that day, fear, terror, anger and horror have been absorbed into the atmosphere too raw and too much to be dissipated even after all these years.

Griffiths is dead, buried in the prison yard, only his initials and the date of execution on a small plate marking his grave, but *something* of him still lives on in that eerie place.

Because the situation was so highly fraught, the very fabric of the jail soaked up the atmosphere as it resounded to the horrific screams of Griffiths. The terror of the condemned man, forcibly dragged from his cell, fighting and shrieking all the way to the gallows, the horror of his slow death and the awful contortions of his face, coupled with the choking noises and jerking of his body, must have instilled unforgettable awe in the people watching, who had no idea what an execution was like.

Small wonder that, over the years, staff at the jail (which is now a heritage centre) have been told many stories of the sounds of his death, heard by visitors and people living on Steeple Lane or the vicinity of the jail, and stories from those who have been witness to Griffiths being dragged soundlessly along the corridor, his mouth open in silent screams.

The majority of phantom scenes fade out with the passing of time, but not, it seems, in this case.

24
THE MONK

Rhos Mynach, a nineteenth-century farm, stands in the tiny village of Nebo in north-east Anglesey. The land has long since been sold off, and it is now just an ordinary dwelling.

About fourteen years ago, a Mrs Thommason and her grown up son came to live there, and found it a very happy and tranquil place to live. She had no inkling that the house was haunted, and was a bit alarmed when people in the village said with real concern,

'How are you getting on up there? Have you seen the monk yet?'

When she asked for more details from an old local man, he told her that when he was young, his grandfather had said that when he was a small boy, a group of his friends would stand at the farm gate and dare each other to go into the farmyard and shout at the ghost to come and show himself. Apparently, the ghost was an apparition of a monk, and although he didn't appear on demand, he had been seen so many times and by such diverse people that his existence was in no doubt.

Mrs Thommason had the house completely renovated, and she told one of the first things she insisted on having done was to have smoke alarms fitted, as she dreaded fire.

'Not long after they were installed,' Mrs Thommason said, 'we were fast asleep in the middle of the night, when we were both awakened by a terrific non-stop clanging – you know what a noise they make. We both shot out of our bedrooms, half asleep and completely disorientated

"What the heck's going on?" my son yelled. Then we realised that the upstairs alarm had been triggered off by something and the noise was deafening. He leapt to switch it off but the switch would not work, however he fiddled with it.

"Take the battery out!" I shouted in desperation. He was quick to do it. We searched all over the house for any signs of fire, plugs, switches, lights, everything, but all was in order, and now that the racket had stopped, all was peace and quiet again. We decided it must have been a short or something but, as everything was OK, we went back to bed.

Two nights later, the one down in the hall did exactly the same thing. Up we shot, and rushed downstairs to see if anything was on fire, but there was absolutely nothing wrong, so out came that battery as well. We put them back again next day, as I am scared of fire.

Well, that wasn't the only instance. It happened again and again, always in the middle of the night, and you can imagine what a shock it is to be wakened by that din. In the end we got sick of wakening up bleary eyed, so we decided we couldn't live with being constantly disturbed – now we have smoke alarms with no batteries in!'

I asked Barbara if there had been any other manifestations and she said that the alarm clock in the back bedroom where she sleeps had gone off several times at exactly two o'clock in the morning. This happened about two and a half weeks before we spoke to each other.

'My son (I'd rather not give you his name) doesn't live here now, but he often comes to stay. Last time he came, he awoke very early in the morning, feeling as if someone was in the room watching him. He was sleeping on his side, and the feeling was so strong he rolled over onto his back and opened his eyes.

There, at the foot of the bed, standing absolutely still and gazing fixedly at him, stood a figure. It was such a shock that he reared up in bed and stared at it.

He told me it was a tall man, dressed in a cassock with a rope-thing around his waist and a cowl over his head. When I asked him what it looked like, he said he couldn't see it properly because the cowl was pulled forward, hiding its face, and all he could see were the eyes glinting.

They stared at each other for what seemed like hours, but was probably only seconds, and then the figure gradually started to become transparent, until he could see the outline of the window behind it, until finally it disappeared altogether and he was staring at an empty space.

I asked him whether it had spoken to him, but he shook his head. I think it must have shaken him a bit, because when I started to ask him questions, he raised his hand to stop me and said firmly, "Look, Mum, I don't want to discuss it any more, OK?"

And he never has.'

25
A GRAVE IN
THE GARDEN

This is a story that has puzzled me for months, so I have kept putting it aside and trying to find any more elusive details, but question as I might, there doesn't seem to be any more information forthcoming.

Therefore, I write it just as I have heard it, and hopefully someone who reads it will solve the puzzle.

A grave in a garden is not really uncommon, many gardens contain the remains of much loved pets, usually cats and dogs, and I have heard of a beloved donkey being buried at Llaneilian in Anglesey.

But in the garden of a house Pengorfwysfa, Amlwch, is the grave of twin boys.

The present house stands on the site of a medieval building and dates back to the fifteenth century, recent renovations uncovered the foundations of a two foot thick wall, which is incorporated into the rear kitchen wall, and contained the ash of an ancient fireplace. The gravestone is immediately behind this.

I first heard of the haunting from Mrs Pat Heany, whose best friend, Mrs Holt, lived in Ling Craig, which is the modern name for the house.

Mrs Heany told me that she had been out shopping with Mrs Holt (who lived alone) and when they returned and put the key in the door, Mrs Heany said the first thing she heard was gurgling and laughter from the living room. It was the sort of noise happy babies make, and Pat Heaney was just going to say that she didn't know her friend had company, when Mrs Holt put one hand on her arm, shaking her head slightly with a smile, and put a finger to her lips.

They both stood silently, and listened to what seemed to be two young toddlers chortling together.

The ladies waited for a moment, then Mrs Holt called, 'I'm home children,' and shut the front door smartly.

There was immediate silence.

Mrs Holt nodded to her friend, and they entered the room where the children were. It was empty.

As Pat told me, 'I couldn't believe my eyes – a minute before I'd heard them as plain as could be, yet there was no one in the room. They were too young to have hidden, only babies, but there wasn't a sign of them – no clothes or toys or all the clutter that surrounds babies in the house.'

She turned to her friend, 'Where are they?' she asked in astonishment, 'where did they go?'

'Not real, they're ghosts,' Mrs Holt said matter of factly.

Pat was standing with her mouth open.

'Sit down and I'll make some tea,' Mrs Holt said to her thunderstruck friend, 'and I'll tell you all about it – or as much as I know.'

Over their cups of tea, Pat sat listening to the silent house, with not a murmur in it, and attended to what Mrs Holt had to tell her.

'There is a grave in the back garden,' she began, 'not an animal's grave, but the grave of two baby boys.'

Pat looked horrified.

'Oh good heavens,' she exclaimed, 'were they murdered?'

'No, sadly I think they died of natural causes – it's over a hundred years ago and infant mortality was very high in those days. When you've finished your tea, I'll show you the grave. I've heard them for ages now. It didn't happen very often at first, never when I was in the room, and at first I thought I was hearing things. I'd be in the kitchen washing up, or making the bed upstairs, and then I'd hear a little laugh, or that kind of shriek that a baby makes when it puts its arms up to be picked up, and when I stopped whatever I was doing and listened, it stopped. But this last couple of years it's just like having babies in the house. Happy babies who make me smile when I hear them.'

'Have you seen them?'

'Sadly, no, but I'd love to,'

'Have you seen the mother and father?'

'Never, but I think they must be near, otherwise the babies wouldn't be so happy, would they?' she asked.

'No, that's true, but could we go out and look at the grave?'

They stepped out of the back door, there was the gravestone, weathered and eroded by time, but the Welsh words are still legible. And this is the inscription.

IN THE MEMORY OF JOHN AND ELINOR DAVIDS
TY FICAR (VICARS HOUSE) LLANEILIAN
WILLIAM WHO DIED MARCH 20TH IN THE YEAR 1858
OWEN WHO DIED MARCH 23RD IN THE YEAR 1858
IN THE YEAR WHO WAS ONE YEARS OLD.

The two ladies, who were not Welsh, could make out most of the words, and Pat Heany felt terribly sad. Some of it, particularly the last line, is very puzzling until one remembers that stonemasons were not all masters of grammar or spelling, but as far as I know that is the correct interpretation.

Both Pat Heany and Mrs Holt are dead now, and Mr & Mrs Geoffrey Goodwin live in Ling Craig. Mrs Goodwin (Chris) had the obituary copied out for me and it was translated by a Welsh educationalist, just as it is.

In my search for the previous history of Ling Craig, Mr Rowland Williams came up with the medieval name of the house, and it was on the land of a knight named Merddyn Mardhog. Since then there are no clues as to why it was called Ty Vicar (Vicar's House) and how the Davids got special dispensation to bury the twins in the garden. I hope someone could kindly shed some light on this subject for me.

However, this does not lessen the fact that it must have been agonising for the parents to lose both boys within three days of each other. Perhaps it was a comfort to have them buried so close to home. According to Mrs Holt, the babies sounded a bit older than a year, and she wondered whether they may have been about fifteen months old. They always seemed happy, according to her, and seemed to have haunted the house consistently and contentedly all the time she was there, although Mrs Goodwin said they had never heard a thing. The only thing she has sensed though, is the feeling that someone is standing behind her in the kitchen, a very strong sense, but when she looks around, no one is there, although she is certain it is a woman.

The Goodwins have a friend who is a lorry driver and of him, Chris says, 'Ted Rigby is a big strapping lad, who isn't afraid of anything, but he can't go in the house, he feels an atmosphere that sends shivers down his spine. Last time he came,' says Chris, 'he forgot and strolled into the house, but suddenly went quite pale and said, "I've got to get out of here", and went abruptly, carrying on the conversation from the garden.'

He does say that the atmosphere he feels is not a bad one – just very strong and overpowering.'

It sounds as if Ted is naturally psychic. I would love to hear the findings of a medium who examined the house.

But as Mrs Holt said, 'Those children lift your heart with their happy laughter. I'd hate to be without them – I'd never be afraid of my little ghosties ever.'

26
NOT WANTED HERE

'My Uncle Dr Kelly,' said Mrs Gwyneth Wood of Amlwch, 'was medical officer for Warwick, and when he retired he moved to a bungalow which had just been built at Penrhos Garnedd, there were three bungalows in a field. After eleven years he died, and his widow lived there alone. Eventually, she left it in her estate to my father.

In 1967, a family party of us from the Wirral went down for August Bank Holiday, there were six of us, mother and father, my brother and his girlfriend, my boyfriend and myself.

On the Saturday, it poured with rain, typical Bank Holiday weather, so in the afternoon we stayed in and played cards. No radio or TV as it wasn't fully furnished.

My Uncle then owned the Crown in Bodendan, and we were going to see him that night and have a sing-song, a few drinks and enjoy ourselves. I don't drink by the way, it's never bothered me, I enjoy myself just the same.

About 4 pm I got out of the chair and said "I'm going for a bath Mum," and she said "Alright love, the towels are in the wardrobe in the front bedroom."

"OK Mum, I'll find them," I said and left them to go upstairs. I walked to the centre of the hall and suddenly I stopped. I felt *paralysed*, I was stuck. I couldn't move forward, I couldn't move backward, and I couldn't open my mouth to speak. I had walked into a place that was absolutely freezing – I've never felt so cold in my life, and all the hackles at the back of my hair stood up. I didn't *see* anything, I didn't *hear* anything, it was just horrible. Then suddenly it was gone, and I ran back into the rear lounge where they all were.

"I don't think I'll bother about a bath Mum," I said. I wasn't going to say anything because they might all think I was a bit stupid, but mum gave me a strange look and said "Are you alright love?" I didn't want to alarm her so I said:

"Yes Mum, I'm fine."

So we went off to Bodendan and had a lovely evening. It was about one o'clock in the morning when we got back, and it was a beautiful night, full moon, gorgeous.

Anyway, my brother's girlfriend (now my sister-in-law) and I had twin beds in the back room. Mum and dad were in the front room, and my brother and Ray were in the other room on the other side. It must have been about two o'clock in the morning when we got to bed. I lay in bed, looking at the full moon over the mountains and thinking how wonderful it was, until I fell asleep.

Then all of a sudden, something woke me. I thought it was a spider, walking across my face, so I went "ugh" and brushed it away. I'm not frightened of spiders.
Me: (Interrupting in horror) 'I am'.

'Oh, I'm not, Gwyn said equably.

Then, it did it again, a sort of crawling feeling going slowly across my face. I tried to brush it away again, but by this time I was properly awake, wondering to myself what the heck was that?

So I opened my eyes, and I got such a shock. There was this *thing*, this apparition and it was bending over me. And it looked like (here Gwyn hesitated, searching for a description, then she went on slowly) it looked just like somebody wearing a nun's habit – a brown coarse material with a hood. I could see it clearly in the moonlight, but the awful thing was, there was not face or head inside the hood, just a hollow, and it was bending over me.

I said, "Oh Ray! Go away!" I honestly thought my brother and my boyfriend were playing silly beggars. So I pushed it and it sort of disappeared.'
I interrupted here. 'Could you feel it when you pushed it? Did it feel solid at all?'

'No, not really. It was the *smell*, the most horrible smell, I can't tell you what it was like – it was awful, and I never want to smell it again.

I sat up in bed, and looked across at Judith. She was fast asleep, it had nothing to do with her and I thought to myself, what on earth was that? I'd had such a shock. I'm not easily frightened, but I shot down in bed, under the covers, I was stiff with fright. Eventually, I fell asleep.

Next morning, nobody said anything, we just had breakfast as normal and after we'd done the dishes, I told mum I'd go and make the bed. I went into the back room first, where I'd slept, and there was my brother Allan and Judith, she was sitting on the bed, and you'd have to know Judith, if she said black was white, you didn't argue. She was very indignant and she was saying to him "Don't you call me a liar!"

"Oh come off it," he was saying, and I said,

"What's all this?"

"Oh she's telling me some cock and bull story about what happened last night and she's blaming me."

"Hang on Allan," I said, "Something happened to me last night."

He gave me a look so I told him exactly what had happened, and he nodded at Judith and said disbelievingly, "She's just told me the same story."

Judith looked at me and said, "When I looked at you Gwyn, you were under the covers."

So we decided that it must have happened to me first, because I never ever slept under the covers. Judith, like me, had thought that the lads were playing silly beggars, but they both swore it had nothing to do with them. When the lads had left, we both sat there in silence for a minute, puzzled, and Judith said, "Gwyn, what was it?"

I said, "Judith, I don't know, but something happened to me this afternoon," and I told her about the freezing cold in the centre of the house, but I asked her not to say anything to mum and dad.

Anyway, nothing else happened that weekend, and Allan and Judith had to go back to Liverpool on Tuesday, back to work. Next day I said to Ray, "It's early closing day today in Bangor, so why don't you take mum and dad to do the shopping and I'll stay here and clean up." So off they went, and I went into the kitchen to do the pots, and I was working away quite happily when it started again.

The place got colder and colder and that awful smell came back, I can never explain it to anyone, it's like no smell on earth. And the dog, the dog was with us, he was curled up fast asleep in the living room. Then I heard him starting to growl, deep in his throat, and next thing he was backing into the kitchen, facing the living room, and he was staring at something he could see there, all his hackles were up, and his eyes were almost popping out. Up to then, I'd felt the paralysing feeling that I'd felt before, but I forced myself to move, it was like breaking a spell, and I dashed into the living room, but there was nothing there.

So we both turned together and flew out of the back door, and when mum and dad came back we were out in the garden. While Ray and dad were unloading the shopping, mum and I went in to make a cup of tea. Mum came straight to the point and said "What's wrong Gwyn? I can tell by your face that something's wrong." So I told her everything and said I would never be in that house on my own again. She thought about it, and said she'd never felt or heard anything, but she believed me. Then she asked me not to say anything to dad. Well, I wouldn't, of course.

We were going home on the Saturday, and my sister Glen, her husband, and their baby were coming down for a week. So they came, and we saw them before we left. They were supposed to stay for a week, and the weather was glorious but on the Monday my mum said to me, "Glen's come home."

"Already," I said, "Why, what's wrong?"

"She just said the baby wasn't well, so they decided to come back."

My sister lives in West Kirby, so that evening I went to see her, and I asked her why they'd come back.

"Oh Gwyn," Glen said. "Don't!"

Now, she didn't know anything about what had happened to me, I hadn't said a word to her, but we had hardly sat down before she started to tell me. "You know we went down on Saturday, well the first night we were there, we put baby Sarah to bed in the front bedroom. Now you know that Sarah is a very good baby, she went to sleep at once. Anyway, it must have been about 9 pm when suddenly we heard the most dreadful screaming coming from the front bedroom, and we both rushed in. All the bedclothes from her cot were in a great tangled heap at the other end of the bedroom and Sarah was screaming, she was absolutely puce. She was in such a state we thought she had colic, so we ran next door but one to a doctor who lived there, and he came in.

He examined her and he said she hadn't got colic and he couldn't find anything wrong with her, she had probably had a bad dream, because babies do dream. Anyhow, she went back to sleep and was quiet for the rest of the night.

On Sunday morning, everything was normal, Sarah had been taken into the garden with her daddy and I was washing the pots. Suddenly I got this awful feeling that something was watching me, something bad, it got worse and worse, and I became absolutely terrified I couldn't explain it to you."

"You don't have to Glen," I said, "the same thing happened to me."

Glen went on, "I ran outside and told Eric, he could see how frightened I was, so he went into the kitchen and I followed him. Everything was back to normal but he believed something had scared me.

Anyway, that night we put Sarah to bed as usual, she hadn't been there long before we heard her screaming. When we rushed in, it was just the same as before, all the bedclothes in a heap miles away from the cot, and Sarah screaming with fear. Well,

enough was enough, there was something in that house that didn't want us there – we could feel it in the atmosphere, it was terrible. We weren't going to put Sarah through that again, so while Eric held her and got her calmed down enough to go back to sleep, I collected and packed all our belongings. Then we packed the car, I got in the back with Sarah and we drove back to Liverpool. It was very late but we couldn't stay in that house for another minute – in fact I'm never going there again."

So I told her what had happened to me when I was in bed and she nodded and said there was something evil in that house. We wondered whether to say anything to dad because he was always going down decorating and what have you. Mum didn't, she wasn't keen, but dad wanted to make it nice so we could all spend our holidays there, then eventually he was going to retire there.

Anyway, a couple of months later, dad had gone down there on a Friday night, intending to stay there decorating for the weekend and returning on Monday. But he arrived back on Sunday, and when I saw him I said, "Hello Dad, I didn't think I'd see you until tomorrow, what's the matter, aren't you well?"

But he just shrugged and didn't answer me. I went straight to the point and said, "Did something happen to you at the cottage?"

Then he stared at me and said, "Why love?"

So I leant on the car and said, "Well, to tell you the truth Dad, I'm never, ever, going to go there again."

Then he rubbed his hand through his hair. "To be quite honest with you Gwyn, a lot of things have happened to me down there, but this one was the last straw."

"Why Dad?" I said.

"Well, I'd been painting outside all day Saturday, and when I'd finished the window sills, I decided to go down to Bangor for a meal. So I went in, had a good wash and changed my clothes. I was in the front bedroom and when I was dressed, I sat down on the side of the bed to put my shoes on, and I bent down and you know that big marble cross that was Auntie Nell's that was on the fireplace mantelpiece? Well, that shot across the room and if I hadn't just bent down to tie my shoelaces, it would have hit me on the head. As it was, it just missed me and crashed into the wardrobe making a big dent, it was thrown with such force. I'm sure if it had hit me, I wouldn't be here now. I've never been so frightened in all my life."

Now my dad has always been a seafarer and it takes a lot to scare him, but I could tell he was very shaken. "Gwyn, we're not having that house, there's something evil in it, I'm putting it on the market."

Sure enough, he put it up for sale the following week and it was sold within a month and that was it. Whether it's still haunted and why it didn't affect my uncle and aunt who lived there happily for eleven years, I just don't know.'

27

FURTHER SIGHTING OF THE NEBO CAT

In August 2005, I received an excited phone call from Mr Mark Wells, who lives at Nebo. He told me this:

'Last winter, I think just before Christmas, I was driving up the road past Home Farm.

I had dropped down the dip and had started to climb up the road with the woods on my right-hand side. It was a clear and pleasant winter's night, calm and moonlit and it was about 1.30 or 2 am.

Driving up the road, all was still, until I suddenly saw this big creature in the middle of the road, lit up by the headlights. It wasn't lying in the road, but standing there and looking in the same direction as I was. When it saw the car, it started to run *fast*, and when I say fast, I mean it. It was big, I thought "what's that?"

I only saw the back of it at first, and I couldn't work out what it was. All sorts of things went through my head – you know, dog? fox? And all that, and I still couldn't figure it.

There is a wall running along the roadside, and over the wall there is a forest. This creature was facing away from me, so I only saw the back end of it as it was running in front of me, then it turned aside with a huge leap and vanished over the wall into the woods.

It was then I saw its tail, a very long thick tail, and I realised it was a big cat, and I mean a big cat, like a puma thing.'

I asked, 'What colour was it? Black, like a puma or tabby?'

'No, it was brown – definitely brown. I was only about ten feet away when it sprang over the wall and into the wood.

I looked to see if it went through the wood, the ground isn't covered in undergrowth, they were pine trees or fir trees, I'm not too sure, I could see right through the trees, but I couldn't see the cat no matter how far I looked, or in which direction.

The way it flew over the wall showed it must have been travelling fast, it was a low wall and I couldn't see any sign of it running along inside.'

Me: 'Perhaps you couldn't see it, because you were sitting in the car?'

Mike: 'No, as a matter of fact that gave me a better view, because I was in a Discovery and sitting about five feet up.

I was mystified. I told my wife about it when I got in, and I've thought about it many times since. I wanted to believe it was a real cat – I saw the whole body length

as it cleared the wall into the wood – then it just vanished – disappeared, absolutely no sound, and it didn't run through the wood.

I've thought about it a lot, and last night I started reading your book, and I said, 'My God! The Nebo Cat!' So I got in touch with you right away. I couldn't confirm the yellow eyes – I never looked, I was so impressed with the thing's size and its speed, and it was all over in a few seconds.

I've come that way many times since, and I keep my eyes peeled all the time, but I've never seen it again.

I'd be glad to know if anyone else has seen it since.

28

TYDDEN MAWR

One of the stories in *Haunted Anglesey* concerned a clipper ship called the *Baltimore* which was sunk by local wreckers in the eighteenth century, and all her crew were drowned.

Subsequently, a hundred years later, when the owner, one Mr Roberts, was away, the house was checked nightly by a Mr Jones to see all was secure.

One night (as I described fully in *Haunted Anglesey*) all was in darkness, except where light pooled out from the kitchen. Creeping quietly up, Mr Jones and his son Owen peered in at an unearthly scene.

Around the kitchen table sat a group of men wearing sailors' clothes of the previous century, complete with tarred pigtails.

Mr Jones and his son retreated silently, and swore for the rest of their lives that they had seen the ghost crew of the doomed *Baltimore*.

So I was more than intrigued to see if Tydden Mawr was still haunted.

Mrs Spencer assures me that it still is. She tells me that none of her family has ever seen a ghost, but one thing happens occasionally that they cannot explain, and it is this.

Although the door to the kitchen (where the Baltimore crew were gathered around the table) is very evenly hung, sometimes the door knob is seen to be turning (as if from the inside) and then the door swings silently open. After a few moments, it slowly closes again, and clicks back into the lock. There are no draughts to create this, like open doors or windows, and even if this was so, how does the knob turn and the door close again?

Also, Mrs Spencer says, sometimes visitors to her house who have occasion to use the bathroom, come rushing downstairs looking very pale, and announce they feel a definite presence on the landing. One visitor re-appeared in the lounge within seconds of leaving it, declaring in a shaking voice that there was an old lady in a black Victorian dress standing motionless in a corner, staring fixedly at her. This has happened many times, indeed some time ago when Mr and Mrs Spencer had friends staying from Liverpool with their children, the children's daddy (John) got up in the middle of the night to see if the kids were alright and he saw the old woman in long black clothes standing on the landing. He was quite shaken and described her very vividly next day to the Spencers, out of the children's hearing.

Nowadays, the ghost is held responsible for any knocks, thumps or odd noises in the house, indeed, they all say cheerfully, 'Come in Mary!'

Mrs Spencer has never seen 'Mary' but she does admit that if she has occasion to use the bathroom in the night – she runs both ways!

29

FLAT IRON MURDER (RED WHARF BAY)

In *Haunted Anglesey* I told the story of how an ex-army sergeant, one Albert Nettleton, killed his wife with a flat iron, and buried her body in the sand of Red Wharf Bay, but his crime was discovered when two ladies rode along the beach and saw an arm sticking up from the sand.

Albert Nettleton was a gentle, good-natured man, married to a very jealous, neurotic woman who was older than he and had made his life a living hell for years.

In early October 1945 she had nagged him relentlessly for a week, and when he took the usual tray of early morning tea to her, she started again. He ignored her tirade, and went back downstairs to continue his task – the weekly ironing.

This infuriated her even more and she flew down after him, picking up the carving knife and waving it in his face. She had no idea how close he was to losing control – he suddenly picked up the iron and dealt her some tremendous blows to the head.

Anyhow – to cut the story short – at his trial his demeanour impressed both judge and jury, he stood erect with military precision, and gave truthful evidence of the murder.

Ivy, (his wife) was well known as a domineering woman, but everyone was surprised when it was revealed in court that she had made Albert sign a 'Seventeen Point Charter' which she had written. Amongst many other things, she demanded that he must do everything she said, her decisions must be unquestioned, no new friends must be made without her consent and he must never look at another woman for the rest of his life.

The sympathetic jury found him not guilty of murder but guilty of manslaughter, and sent him to prison for five years.

He was such an exemplary prisoner that this sentence was shortened.

The sad epilogue to the story is that when he was released from prison, he applied for a job in an engineering works, telling the whole story at his interview.

The owner of the works (like the judge and jury) was so impressed by Albert Nettleton's honesty, he gave him the job.

Twelve months later, unable to live with his guilt, Nettleton committed suicide.

This is the condensed version of the tragic story, which I thought had ended there – until I opened my post in September of this year (2007).

One letter, written in faultless copper-plate handwriting was from a lady called Evelyn Pritchard – and this is what it said:

Dear Mrs. Austin,

My name is Evelyn Pritchard. On my eighty-seventh birthday on 22 July 2007, I was given the Haunted Anglesey book by my daughter.

I was amazed on turning to page 128, and seeing the 'Flat Iron Murder.'

My late husband Hugh Richard Pritchard had joined Anglesey Police Force and was stationed at Holyhead, but like many others was called to fight for King and Country until 1945.

We were married in June 1942, and while he was away I was home on the farm in Holyhead.

Hugh restarted his police duties at the Holyhead Police Station on the 10 pm – 6 am shift guarding Albert Nettleton in his cell.

The following night when I was preparing Hugh's food box for his 3 am meal, he asked me to put another two slices of bacon and an egg in, which I did, thinking he had missed them whilst in the army.

The following morning when he came home, he told me the whole story exactly as you have it in your book, and from then until he was taken from Holyhead, there was a food parcel for Mr Nettleton whatever the shift.

He was a real gentleman Hugh said, who had married the wrong woman.

Congratulations on writing such an interesting book.

I've often wondered if Hugh's name is in a Police Book regarding this case, I suppose they've been destroyed by now,

 Yours faithfully,
 Evelyn Pritchard.

P.S. Hugh's first Station was Amlwch Port!

Well, after receiving this wonderful letter, I rang the collators office at Holyhead Police Station, Sadly, they have no records that go back that far, so no joy there. Anyway, it was a delightful and unexpected codicil to the Flat Iron Murder.

30
POST HORN GALLOP

It wouldn't be Christmas unless we all got at least one of the most traditional cards depicting a mail coach arriving at an inn yard, usually on a snowy evening with the lamps casting a warm glow.

The portly cheerful driver, wrapped to the neck in a voluminous driving coat, complete with many layers of cloth on the shoulders, and a warm blanket around his legs, is beaming happily above the steaming breath of his four horse team.

Smiling passengers are looking out of the windows, and the outside travelers are peering expectantly at the open door and lit windows of the inn, with the promise of huge log fires and hot food.

All is bustle, excitement and happiness as the coach clatters in.

Is it?

This isn't the present day method of traveling remember – this was Georgian times, and believe me, we've come a long way since then.

In the first half of the eighteenth century, each parish was responsible for the upkeep of their roads, some councils, being too thrifty in their methods, allowed their section to become badly potholed, miry, or even flooded. The mail coaches had to keep their speed however, to make their times of arrival reliable, as competition by rivals was fierce. Fares weren't cheap, the poorer folk or servants traveled outside up on the roof behind the driver, which would cost them 3 pence per mile (in old money) and 5 pence per mile to travel inside. Fares were paid to the innkeeper at each stage of the journey.

Even traveling at a furious rate, the horses took one hour to travel between 7 and 10 miles. Remember this team of four would be hauling the coach, passengers inside and out, their luggage, coachman and guard, and the precious mail. This was stashed in a large box at the back of the coach., on a level with the outside passengers, on it sat the guard, complete with blunderbuss and the post-horn, which was blown well before the toll gates were reached, telling the keeper of their imminent arrival, thus ensuring the gates would be thrown open for the mail coach to flash through.

The poor unfortunate souls who traveled on the outside of the coach, were given the luxury of a cushion to sit on, but they were at the mercy of the elements, and in winter, heavy rain, sleet or snow, soaked them to the skin, making the cushions sodden and useless.

Inside travellers didn't fare much better, comfort was hard to find early in the century. Deep straw was spread upon the floor at the beginning of the journey, the seats and

back rests were filled with horse hair – and at first glance everything was comfortable enough. *But* – inside the coach, room was minimal, people were squashed together, and any six-foot tall man was in agony after a few miles.

If it was winter, and snowing, passengers would climb in with big clumps of melting snow on their boots, so that very soon the straw would become a wet, cold mass, and everyone's feet (particularly the ladies in their dainty shoes,) would be freezing. The horse hair stuffing of the seats sometimes harboured infestations of head lice and fleas who would leap joyously onto the heads of passengers, who were usually a conglomerate bunch, thin and fat, drunk or sober, all herded together.

There were no springs on the coach, strong leather straps slung underneath, keeping the coach aloft, so at every pothole or large stone, the hapless passengers were lifted or dropped and constantly thrown together. The results were a rolling motion like a ship, so the people were sometimes very travel sick.

Add to this the pungent smells (personal hygiene did not figure large in Georgian times) and tightly closed windows, there was no heating of course, and the atmosphere quickly became rank.

The coach was perched very high over a strong ash pole, which ran the whole length of the coach, and the rear wheels were larger than the front. If some wooden spokes broke, or a wheel fell off, everyone fell into a struggling undignified heap.

There are records of a mail coach traveling in the Peak District of Derbyshire, where the coach driver would rein in before climbing a very steep hill, climb down from his unsprung uncomfortable driving seat, and announce sternly to the passengers—

'Gentlemen, the button is off.'

And the able bodied males would get out, and tramp dutifully uphill, behind the slipping swaying coach.

Taking the button off the whip and disgorging the weight of the men, meant the driver could lash the unfortunate floundering horses through the snowdrifts, then wait at the top for the cold hapless men.

Christmas brings thoughts of coaches as we said, but also thoughts of ghosts, not only Marley's ghost – but our local ones, which we have in abundance.

Take Gwindy, for instance – the ivy clad ruin that looms ominously on the front cover of my previous book *Haunted Anglesey*.

Gwindy was a thriving coaching inn, the second and last of the two staging posts on the old road between Menai and Holyhead, before Telford built the A5.

Even on Anglesey, sometimes the cold was so severe, especially when the icy winds were driving needles of snow at the hapless outside passengers, many would suffer the agonies of hypothermia, huddled together for warmth in the nightmarish conditions.

That was exactly the scene that started the haunting of Gwindy, which continues today. Here is the story.

One John Hughes, joiner, was traveling to Dublin from Chester to take up new employment with his cousin Joseph, who was already working on a grand new house in Dublin.

He had been out of work for months, he told his fellow passengers, and had been doing all sorts of odd jobs to save the money for his fare. He looked thin and undernourished, his clothing was scant, and he did not even have an overcoat.

Only the poorest people rode outside the coach, and John sat on the rear forward facing bench, on the thin cushions provided. No luxuries were offered to those traveling on the roof, and none were expected.

To begin with, at the start of the journey, John was excited and talkative, but he had eaten nothing all day, and the bitter wind caused him to shiver, and his talk died away as his teeth began to chatter constantly.

Gradually he became as stiff as a board. White faced and blue lipped, as hypothermia took hold, and he was only semi-conscious.

As the coach reached Gwindy at last the passengers inside peered out at the cheerful glow of light streaming out from the Inn windows, with the comforting thoughts of food and warmth.

The coach made a sudden and swift left handed turn into Gwindy yard, and as it lurched over the well worn pot-holes, the movement jerked the passengers violently.

John, too stiff to grasp anything for support, toppled helplessly over the side of the coach with a terrified scream which was cut off abruptly as the huge rear wheels of the heavily weighted coach ran over and crushed the life from his frail body.

His scream was echoed by the ladies inside who saw him plummet to his death.

This started the haunting of Gwindy. First the horrific scream rings out suddenly in the still darkness of a winter's night, then the echoing screams of the passengers. The shouts of the men are heard, neighing of startled horses, clip-clopping of hooves, and the creaking of the coach as it lurches over the body.

Many local people have heard the noisy babel of sound, which only seems to last a few eerie moments before it stops abruptly, as if someone has pulled a switch.

No such horror for the travelers of today, so when you have bought your cheerful Christmas cards, and are going homewards, gliding smoothly along in your heated cells, spare a thought for yesteryears passengers in their seated hells!

FURTHER READING

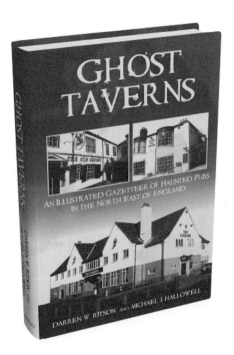

Ghost Taverns

Darren W. Ritson and Michael J. Hallowell

Amberley Publishing, 2009

ISBN 978-1-84868-140-8

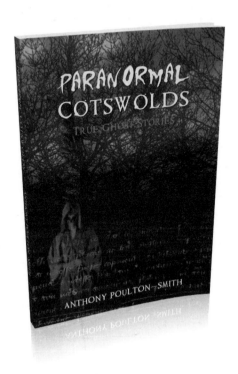

Paranormal Cotswolds
Anthony Poulton-Smith

Amberley Publishing, 2009

ISBN 978-1-84868-170-5